IMAGES
of America

BRANSON

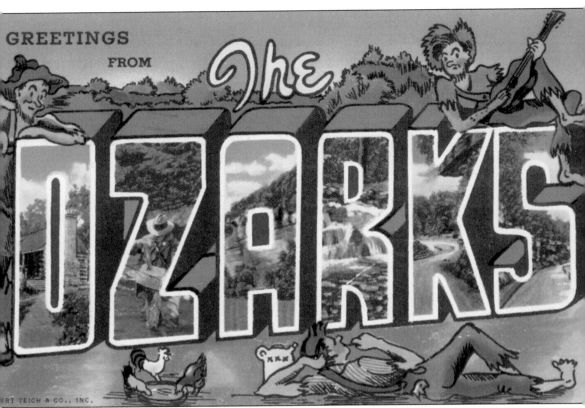

This 1962 "Greetings from the Ozarks" postcard depicts the stereotype of the Ozarks hillbilly, while displaying the unspoiled beauty of the area's lakes, forests, scenic vistas, and historic locations within the word "Ozarks." (Author's collection.)

ON THE COVER: Pictured during the early 1940s, an unidentified float guide poses beside an Owen Boat Line johnboat. Painter and muralist Thomas Hart Benton (right) relaxes in a chair in the front of the boat. His son Thomas Piacenza Benton sits behind him on a pile of supplies during a White River float trip. Several of Benton's paintings reflect his visits to the Branson area and the White River. (Courtesy of Ralph Foster Museum.)

IMAGES
of America

BRANSON

Anita L. Roberts
with a foreword by Jean Babcock,
curator of the Branson Centennial Museum

ARCADIA
PUBLISHING

Published by Arcadia Publishing
Charleston, South Carolina

Printed in the United States of America

Library of Congress Control Number: 2014941890

For all general information, please contact Arcadia Publishing:
Telephone 843-853-2070
Fax 843-853-0044
E-mail sales@arcadiapublishing.com
For customer service and orders:
Toll-Free 1-888-313-2665

Visit us on the Internet at www.arcadiapublishing.com

Dedicated to Bill Lee for picking up the slack while I wrote this book

CONTENTS

FOREWORD

From its source in northwestern Arkansas, the White River flows north, then turns east across southern Missouri before bending south to cross Arkansas and its junction with the Mississippi near the Louisiana border.

It was on the shores of Branson's Lake Taneycomo, created by the first of the five dams built to tame the *Rio Blanco*, that I met Anita Roberts. We quickly discovered we were both curious about this area of the southern Missouri Ozarks and its inhabitants, from Osage Indians to talented entertainers.

We learned that Branson's first permanent residents were a teenage couple and their infant son in 1838. Calvin Gayler claimed a presidential land grant at the junction of Roark Creek and the White River, which included what are today North Beach Park and the north end of the Branson Landing. By the Civil War, Gayler owned the White River shore upriver to near the intersection of Highway 76 and Fall Creek Drive, across from the Dixie Stampede. His wife, Cassandra Gayler, donated a plot from their property for a Civil War cemetery. Old Branson Cemetery lies at the intersection of Oklahoma and Commercial Streets, just north of downtown Branson.

Anita's idea for this book developed as she researched information about the area and I sorted boxes of photographs, news clippings, and personal papers gathered for a museum. I became the curator of the Branson Centennial Museum, which opened on April 1, 2012, the 100th anniversary of the City of Branson's incorporation.

No history can be confined to a specific area since people and events scatter. Thus, this Branson story includes information about Taney County, the county seat at Forsyth, neighboring Stone County, and outsiders who influenced Branson's development.

The author and the curator know by reading this bit of Branson history, your curiosity will be tweaked. The Branson Centennial Museum, the White River Historical Society Museum in Forsyth, the City of Branson, and the White River Valley will welcome you.

—Jean Babcock
Curator of the Branson Centennial Museum

ACKNOWLEDGMENTS

I would like to thank the following persons and/or institutions for their assistance in the completion of this book: James and Jean Babcock, curators of the Branson Centennial Museum (BCM); Leslie Wyman, managing director of the White River Valley Historical Society (WRVHS); Jeanelle Ash, curator of the Ralph Foster Museum at the College of the Ozarks; department head David Richards, archivist Anne Baker, and archives specialist Tracie Gieselman-Holthaus of the Missouri State University Special Collections and Archives (MSU); the Springfield Museum on the Square; Renee Glass and John Rutherford of the Springfield–Greene County Library District (SGCLD); Gwen Jeffries of the First Baptist Church of Springfield, Missouri; and Susan E. Vermillion, director of communications for the Kanakuk Kamps. I also appreciate the efforts of the following from the Missouri Department of Transportation (MoDOT): Mike Meinkoth, historic preservation manager; Renee McHenry, librarian; and Charles M. Hiebert, customer relations manager. My gratitude goes to Nancy Brown Dornan for sharing the photographs of her grandfather, Domino Danzero, and to Pam Jones for sharing the photographs of her aunt, Lucile Morris Upton. My special thanks go to Dr. Carol Chaney, Gerry Chudleigh, Dave Hadsell, Irene Maupin Johnson and her son Bill Johnson, David O'Neill, and James Owen for sharing their personal photographic collections and to James Barrett for sharing his extensive book collection. I would also like to thank Maggie Bullwinkel, publisher, and Liz Gurley, acquisitions editor, of Arcadia Publishing for their patience during the completion of this book.

INTRODUCTION

Branson is located in the Ozark Mountains of Missouri, along the White River. The White River has been the lifeblood of the upper White River Valley ever since the Osage first called it home. Early explorers often arrived in the area via the White River. By 1838, settlers such as the Gayler family began laying claim to land, which became the town of Branson. These adventurous souls settled along the White River. The abundant freshwater fish and the plentiful wildlife made the Ozarks an ideal location to make a new life.

As the area developed, the White River became a commercial hub, with gristmills springing up along its banks and on its tributaries. These water-driven mills ground grains into flour and meal while the sawmills turned timber into lumber. Farmers relied on the river to transport their products and to bring them letters and newspapers, which arrived in the Branson area by steamboat. The coming of the Missouri Pacific Railroad required railroad ties, which were created from lumber harvested in the hills of the Ozarks and then floated out on the river.

Ferries provided easier access to the other side of the White River, and bridges and dams were not far behind. Homes and businesses were built in close proximity to the river as the population increased with the development of Branson and the surrounding towns. While living and working in the floodplain was convenient, it also made the citizens and their property vulnerable.

Historic floods have nearly destroyed Branson ever since its incorporation in 1912. But the determined founding families persevered. As the area became more dependent on tourism, attempts were made to overcome and control the flooding.

The Empire District Electric Company's Ozark Beach Dam, otherwise known as the Powersite Dam, was built in 1913, creating the 22-mile-long Lake Taneycomo. Unfortunately, Powersite Dam did not control the flooding, and in 1958, Table Rock Dam was built. Following the completion of Table Rock Dam, Branson residents believed their flooding problems were behind them; however, heavy spring rains in 2011 caused widespread flooding in Branson and the surrounding area.

Not only has Branson been plagued by flooding, it also has been the victim of several fires. Within five months of Branson's incorporation in 1912, the majority of its business district was destroyed by fire. Despite rebuilding with fireproof materials, a fire occurred on the same site just over a year later. Branson bounced back, stronger and better than before.

Branson has continued to grow and change, repeatedly reinventing itself. Over the years, Branson has evolved from the rural community of Reuben Branson's era to the fishing and float trip mecca of the 1930s and 1940s with Jim Owen and Charlie Barnes to the Live Music Show Capital of the World, begun by the Baldknobbers Hillbilly Jamboree Show in 1959.

I hope these historic photographs of Branson will entice you to look beyond the Highway 76 strip to the people and businesses that have built Branson into what it is today. Please visit the Branson Centennial Museum in historic downtown Branson and the White River Valley Historical Society in Forsyth, Missouri, for more information on Branson's history.

One

OZARKIANS

Around 1880, Reuben S. Branson settled along the freight road between Harrison, Arkansas, and Springfield, Missouri, near what would become Kirbyville. His mercantile became the Branson post office in 1882. Selling out two years later, Reuben became the Taney County assessor. His brother Galba Edward Branson became the Taney County sheriff. On July 4, 1889, Galba was murdered while disarming three drunken brothers. On May 15, 1890, Reuben validated his homestead claim before Taney County probate court judge William B. Burks. The witnesses to Reuben's continuous residency included Thomas Jefferson Berry, Samuel Allen Burks, William H. Hawkins, and William S. Stockstill. During the Civil War, Berry served as lieutenant with the 3rd Missouri Cavalry. Reuben Branson was circuit clerk and court recorder when Burks married Mary E. Biers. Later, the Burkses named a son after Reuben. Hawkins was Branson's second postmaster when the name changed to Lucia, then back to Branson again in 1904. Stockstill enumerated Taney County for the 1890 US Census. The Branson family became rooted in the community. (Courtesy of BCM.)

Mary Thomas Cooper Branson, daughter of John B. Cooper and Lucy Cox Cooper, passed away on January 19, 1931. Just over four years later, her husband, Reuben, passed away on February 10, 1935. R. Oscar Whelchel was the undertaker in both cases. The Bransons were buried in the Branson City Cemetery, which is located at the northwest corner of Oklahoma and Commercial Streets. (Courtesy of WRVHS.)

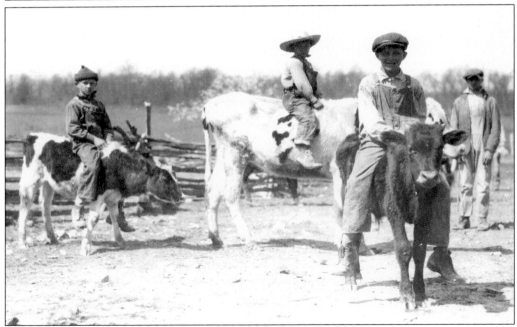

Chickens, cows, dogs, and hogs were common on Ozarks farms. In 1900, the government-owned forests permitted free-range cattle and domestic hogs. Feral hogs, called "razorbacks" due to the ridge of coarse hair along their spines, were common in the Ozarks. Today, they cause property damage and spread disease. Hunters are encouraged to shoot on sight. Around 1900, these unidentified boys posed on their "pet" cows. (Courtesy of MSU.)

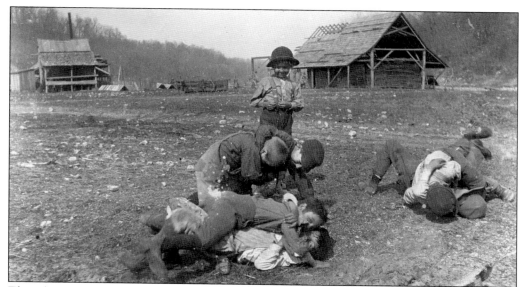

These boys wrestle in the rocky soil of the Ozarks around 1900. At that time, a formal education was difficult to receive, and school attendance was not mandatory. Schools were available by subscription, which meant local families were contracted to pay the teacher's salary. Most families could not afford the cost of wages and books nor spare their farm laborers. Many believed school attempted to alienate children from their local traditions. (Courtesy of MSU.)

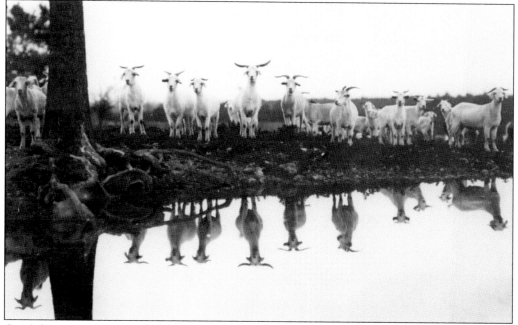

Ozark homesteaders usually had one or two milk animals. The brushy pastures of the Ozarks were ideal for Spanish goats, which could control brush and thrive on almost anything, including briar patches and rocks. Both curious and intelligent, goats make excellent pets; plus, their milk provides for delicious cheese. Around 1900, a photographer across an Ozarks pond piqued the interest of these goats. (Courtesy of MSU.)

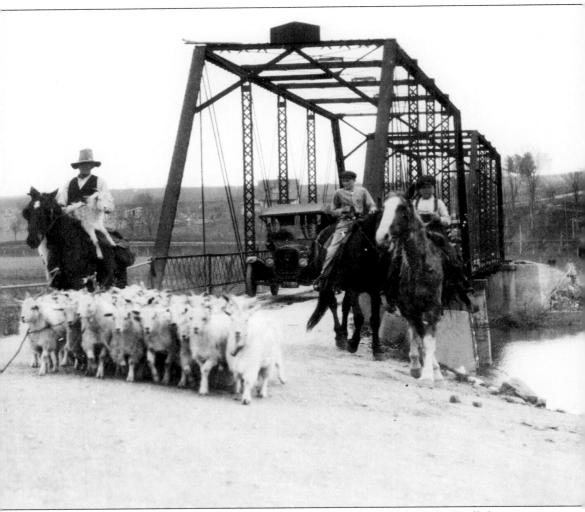

In December 1921, the *Springfield Leader* newspaper reported that Charles E. DeGroff, the secretary-treasurer of the American Angora Goat Breeders' Association, was moving its headquarters to Branson. By 1914, DeGroff owned the largest Angora goat herd in the Ozarks. Goats served a dual purpose on his ranch near Marvel Cave. They cleared the land and yielded mohair. Born in Wisconsin in 1861, DeGroff came to the Ozarks as a photographer. With photographs, DeGroff documented the examination of what was then known as Marble Cave in 1892. In February of the following year, *Scientific American* magazine reported on the exploration of the cave by DeGroff, a US Geological Survey representative, and Edmund O. Hovey, supervisor of the Missouri mineralogical exhibit at the 1893 Chicago Exposition. (Courtesy of MSU.)

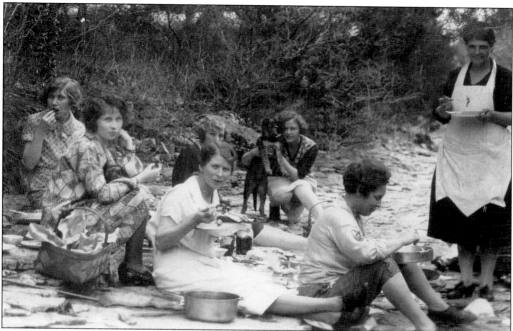

Through the early 1900s, Ozarks women were stereotyped as "ignorant, barefoot, and pregnant," while economics told the real story. Most Ozarks families could not afford a formal education. Women married young and had several children for farm labor. Accustomed to making do without them, shoes were saved for school and church. After the Depression, Virginia Walters Meyer (left) and Minnie Whelchel (standing) shared a riverside picnic with several unidentified women. (Courtesy of BCM.)

In September 1904, this young girl was photographed at the family butter churn in Branson. The thin soil of the Ozarks plateaus made good pastures for small dairy herds. In nearby Springfield, a significant butter and cream industry formed. Following World War I, 650 people produced churned butter in Springfield's creameries, which ranked fourth in the nation for dairy production. These creameries provided a market for the small Branson dairy farmers. (Courtesy of MSU.)

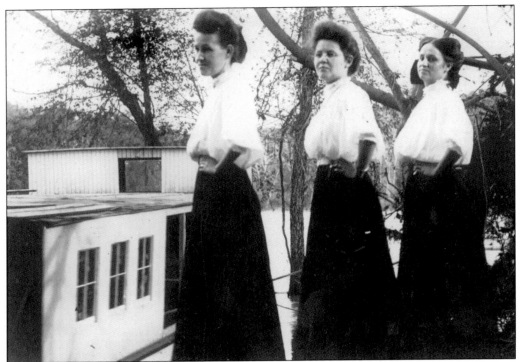

Photographed above the bank of the White River in 1907 are, from left to right, Della Newton, Hazel McHenry, and Maud Parrish. Hazel was the assistant to the Branson postmaster, Higdon Melton, and sister-in-law to Frank A. Forbes, the publisher and editor of Branson's first newspaper, the *Branson Echo*. At the printing office, Hazel's alias was the "Printer's Devil." Maud Parrish attended Forsyth School and became the assistant teller at the Bank of Branson in 1910. (Courtesy of BCM.)

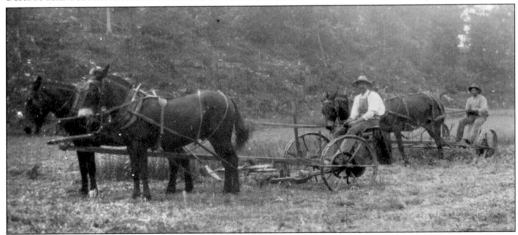

R. Oscar Whelchel (left) and Norwood Speight were photographed on horse-drawn ploughs. An unsatisfied customer kidnapped Speight, manager of the White River Valley Electric Co-operative, in 1961. Speight was released after cutting down a tree that had inhibited electricity to the kidnapper's farm, but a standoff with 27 police officers would claim the kidnapper's life. Whelchel and his wife, Minnie, a mortician, ran the Whelchel Funeral Home in Branson for many years. (Courtesy of BCM.)

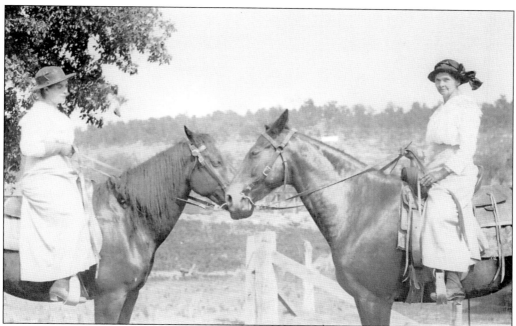

Photographed on horseback in 1918, Sarah Bennett (left) and Minnie Whelchel were owners of the Whelchel-Bennett Millenary Store. Both extremely skilled at designing and trimming ladies' hats, they carried a large and varied stock of head wear. Sarah's husband, William H. Bennett, was the purchasing agent for the American Pencil Company in Branson before becoming partners with Minnie's husband, R. Oscar Whelchel, around 1911. (Courtesy of BCM.)

Dressed for shopping in Springfield are, from left to right, Minnie Walters Whelchel, Eula Whelchel Thornhill, Leah Kingdon, and Josephine Madry. A licensed embalmer and funeral director for many years, Minnie lived to be 92 years old, while her friend Leah lived to the age of 95. Minnie's daughter Eula and her friend Josephine co-owned and ran the Anchor Travel Village. (Courtesy of BCM.)

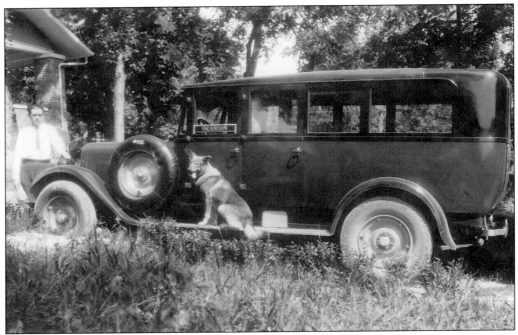

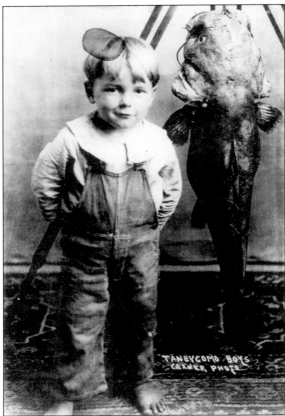

After marrying Eula Whelchel, Percy Allen "Bob" Thornhill managed both of her family's businesses: the Whelchel Funeral Home and the Whelchel Hardware Store. In 1929, he was elected as the first president of the White River Boosters League board of directors. Three years later, he became the Taney County coroner. Bob and his coroner ambulance were photographed at their Main Street home. The Thornhills also co-owned the Anchor Travel Village with Josephine and Buford Madry. (Courtesy of BCM.)

Born in Branson in 1911, three-year-old Harold Edward "Buster" Mead was photographed beside a catfish that was bigger than him. By 1920, Buster; his two sisters, Helen and Evelyn; and his parents, the first Harold "Buster" and Lela, lived on Maple Street. Their father was a Head Transfer Company drayman then, but by 1930, he owned a restaurant. Young Buster, a newlywed, worked there as a waiter. (Courtesy BCM.)

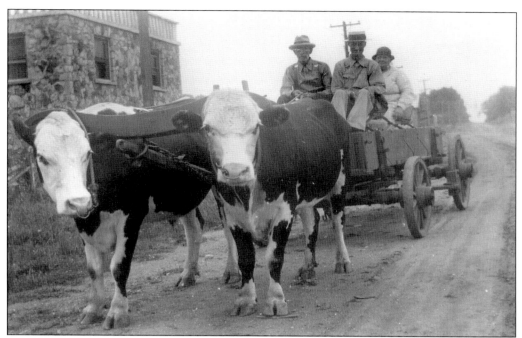

About 1930, Jim "Gemes" Whorton drove his team of oxen down Commercial Street in Branson. Almeda Thorpe Whorton rode in the second seat of the buckboard wagon, and one of their four sons was probably the man seated next to Gemes. The Whortons used this oxen team on their farm and were known to be hauled everywhere by them, including to church and into town. (Courtesy of BCM.)

By 1898, telephone service had become available in Taney County. Local communities organized neighborhood telephone companies whereby members contributed about $5 and donated several days to installing poles. The Parrish-Tollerton Telephone Company, owned by J.H. Parrish, James A. Tollerton, A.L. Parrish, and S.W. Boswell, brought service from Forsyth to Branson in 1903. Switch operators, like this unidentified woman, worked from their homes, often without compensation. (Courtesy of BCM.)

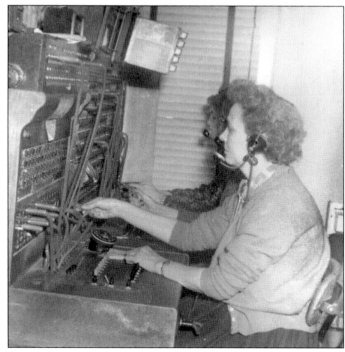

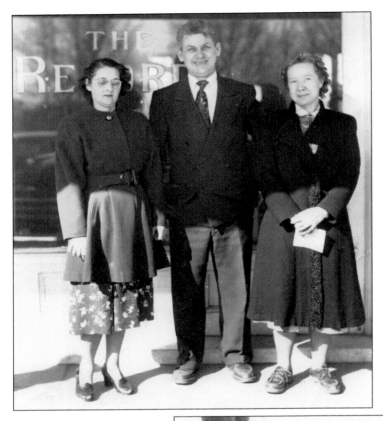

Minnie Freeland initially ran the *Taney County Republican*, and her husband, Senator William E. Freeland, worked as a US government Indian agent. Their daughters, Frieda Freeland Ingenthron (left) and Maude Freeland, pose at the *Republican* office with Isaac M. Thompson. A member of the first Branson High School graduating class, Thompson owned the Thompson Insurance Agency. The Freeland family later published the *White River Leader*. (Courtesy of WRVHS.)

In 1958, from left to right, Catherine "Katie" Ethel Ingenthron Everett and her sister Florence Alma Buntie Ingenthron Whitley visited with Almeda Edwards Brittain. The Ingenthron sisters were the aunts of Elmo Ingenthron, author of local history books, including *Bald Knobbers*. As the "Woman Preacher of the Ozarks," Brittain began preaching in 1924, when preaching was considered a man's profession. Betty Lou Edwards Coffelt was a Skaggs Community Hospital secretary. (Courtesy of WRVHS.)

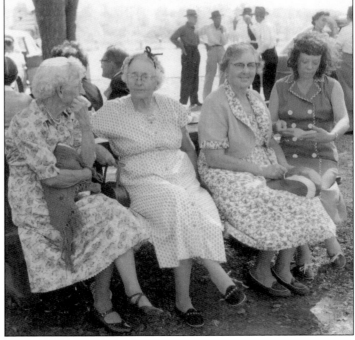

Named for M.B. and Estella Skaggs (founders of Safeway Grocery Stores), the Skaggs Community Hospital opened as a 25-bed facility on January 8, 1950. Initially, Skaggs employed five physicians, six nurses, and six nurse's aides, who treated approximately four patients per day. From left to right are Dr. Harry Knowles, Dr. Joseph Bunten, Dr. Francis Aubin, Dr. Daniel Layton Yancey, Dr. Jesse Threadgill, Dr. Durward G. Hall, and Dr. Harry Evans. (Courtesy of WRVHS.)

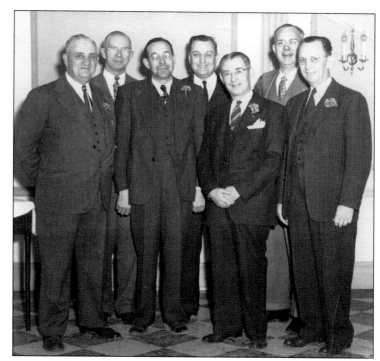

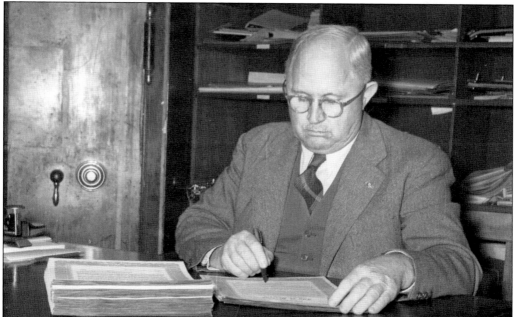

As early as 1925, the Binkley Motor and Machine Company of Branson advertised quality Chevrolets at a low price. On March 4, 1934, Claude Binkley, owner of the Chevrolet dealership, was in the Bank of Branson when three armed bandits stole $1,000, escaping in a Chevrolet. In 1949, Binkley defeated W.Y. Brown when Branson's mayor, Jim Owen, declined seeking reelection. Binkley served two terms, from 1949 to 1951 and 1951 to 1953. (Courtesy of BCM.)

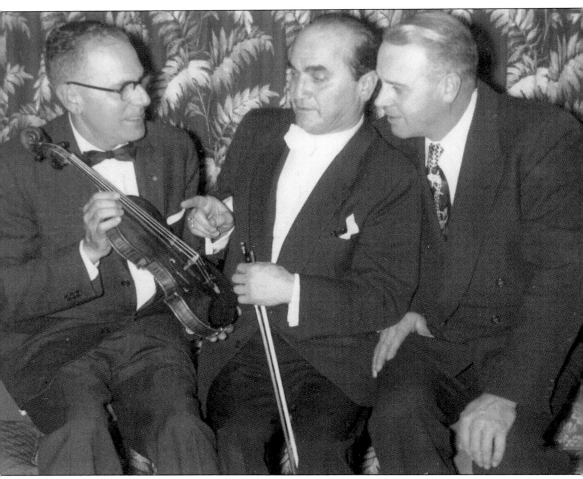

World-renowned violinist, conductor, and composer David Rubinoff (center) displayed his favorite violin to Dr. M. Graham Clark (left), president of the School of the Ozarks, and Warren Cook (right) during a visit to the Ozarks in the 1950s. Insured for $100,000, the Romanoff Stradivarius was made in Cremona, Italy, by Antonio Stradivari in 1731. It was once owned by the Romanoffs, onetime rulers of Russia, and bore the bejeweled crest of their family. During the Russian Revolution, the violin was smuggled out of Russia, and it was eventually purchased by Rubinoff. He often carried the violin around with him handcuffed to his wrist. From 1931 to 1935, Rubinoff performed as a regular with Eddie Cantor on NBC Radio's *The Chase and Sanborn Hour*. Rubinoff's career took him to small towns across America, where he once gave 13 concerts in one day in Hannibal, Missouri. Rubinoff was equally at home in large concert halls and even at the White House, where he performed for Presidents Herbert Hoover, Franklin D. Roosevelt, Dwight D. Eisenhower, and John F. Kennedy. (Courtesy of WRVHS.)

Two

LIVING AND LEARNING

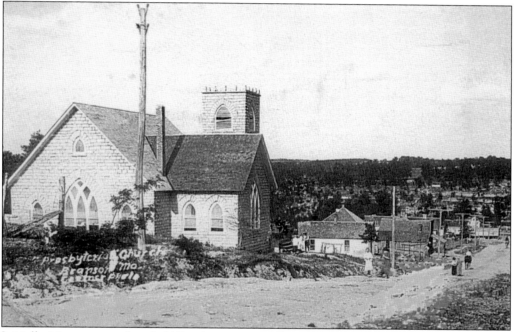

Initially, itinerant preachers held Sunday services in Branson's new school. Following the coming of the railroad, Dr. Elizabeth McIntyre sought to bring organized religion to Branson. Rev. Lynn F. Ross of Lamar, Missouri; Rev. Clarence D. Phend of Worthington, Missouri; and Rev. A.Y. Beatie of Springfield, Missouri, were instrumental in the construction of the first church, which was the first stone building in Branson. They held revivals, and the townspeople pledged $800 toward a church building fund. To raise the funds, they held pie suppers, ice cream socials, and taffy pulls. The Branson Townsite Company donated lots for the church, and contractor J.E. Booth utilized mainly volunteer labor for the construction. The Branson Presbyterian Church was dedicated on April 2, 1911. During World War I, the church ladies knit sweaters and wrapped bandages, while the men greeted the trains carrying caskets of battlefield casualties and victims of the influenza epidemic. The old stone church was converted to a recreation center in 1966, when the congregation constructed a new building. (Courtesy of WRVHS.)

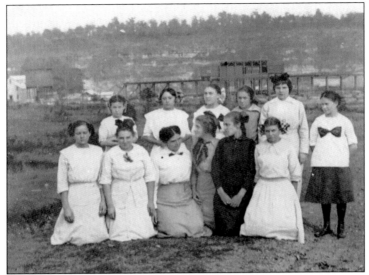

The girls from the Sunday school class of the First Presbyterian Church of Branson were photographed in the field next to the church in 1915. The fourth girl from the left is 16-year-old Eula Whelchel Thornhill, who later became owner of the Anchor Travel Village. The rest of the girls are unidentified. The Branson water tower and the Missouri Pacific Railroad cars are visible in the background. (Courtesy of BCM.)

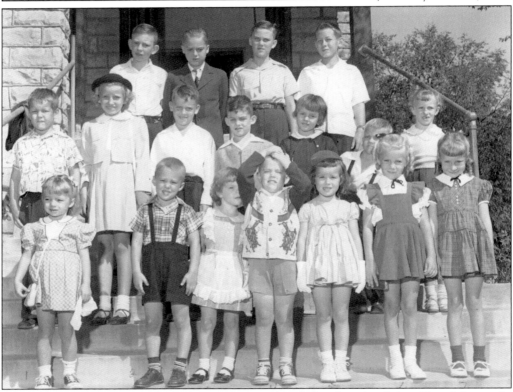

Photographed about 1950 is the First Presbyterian Church Sunday school class. From left to right are (first row) unidentified, John Justus, unidentified, Brent Speight, Kathy Owen, Donna Brown, and Judy Biggs; (second row) Max Thornton, Gail Speight, Larry Davidson, Larry Howe, Mary Yandell, Larry Moldenhaur, and Lawana McComas; (third row) Charles Hirsh, Bob Alexander, Donald Howe, and J.B. Thornton. After 1966, the church became a Community Adult Center and Christian Action Ministry. (Courtesy of BCM.)

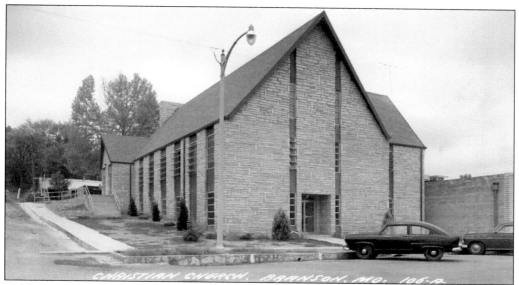

Celebrating its 90th anniversary on June 24, 2014, the Branson Christian Church is one of Branson's oldest churches. In 1925, the Christian Women's Fellowship purchased the corner lot at Commercial and College Streets for $290. By the fall of 1926, the Ladies Aid Society held meetings in the basement. Benjamin "Albert" and Opal Parnell donated two lots. Then, in 1973, the Parnell family donated a stained-glass window in Albert's memory. (Author's collection.)

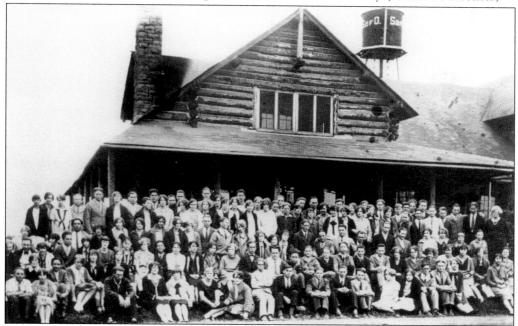

In 1906, Presbyterian missionary James Forsythe began the School of the Ozarks in Mitchell Hall (named after K.M. Mitchell), which was located on Mount Huggins (named after Louis and William Huggins). When it burned in 1915, the Maine Lodge was purchased and renamed Dobyns Hall for William R. Dobyns, school administrator. Students, faculty, and staff were photographed in 1927, three years prior to the fire that destroyed Dobyns Hall. (Courtesy of Ralph Foster Museum.)

23

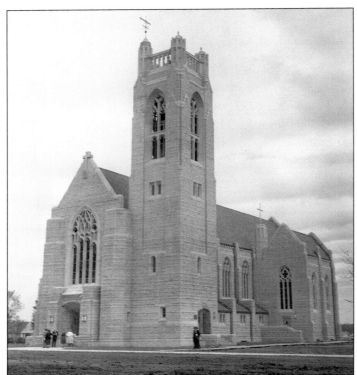

Dedicated in May 1958, the Williams Memorial Chapel was built near the original Dobyns Hall site. An excellent example of Neo-Gothic architecture, the chapel measures 150 feet long by 80 feet wide, with an 80-foot-high vaulted ceiling. Its stained-glass windows depict Bible stories, and the pews and woodwork were constructed in the school's furniture plant. Attached to the chapel is the Hyer Bell Tower, with a 96-bell carillon. (Courtesy of Ralph Foster Museum.)

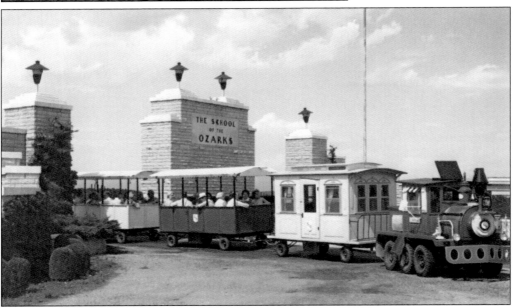

During the Depression, the School of the Ozarks gave fruitcakes to donors. Today, students bake over 40,000 fruitcakes annually. In 1967, Mrs. W. Alton Jones of Maryland donated nearly $1.5 million for the Nettie Marie Jones Learning Center, as well as the *Campus Special*, a motorized train used for campus tours through the mid-1980s. Students initially used a megaphone during the tour, but later, a tape recording was played. (Author's collection.)

The School of the Ozarks began as a work-study school for students who could not afford an education. Students were given the opportunity to work for their schooling by cooking, cleaning, washing, ironing, plowing, planting, harvesting, tending animals, and chopping wood. Although the school earned the nickname "Hard Work U," not all of the school's activities involved study and physical labor. The school sponsored many wholesome social and recreational activities, such as baseball and basketball. At right, two unidentified students are dressed for a 1920 masquerade party held in the gymnasium; below, two unidentified students examine a bull buffalo donated by an unidentified area farmer. Buffalo eat one-third of what cows need; as a result, their meat is delicious, nutritious, and lower in cholesterol than skinless chicken. (Right, courtesy of Gerry Chudleigh; below, courtesy of Ralph Foster Museum.)

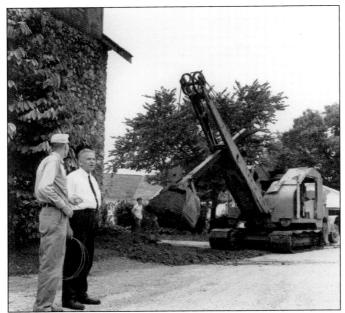

Unidentified men watch the construction of a new building financed by radio pioneer and philanthropist Ralph D. Foster, which began on June 30, 1967. Named the Ralph Foster Museum, it houses his private collection of thousands of antiques, firearms, and fine art pieces while representing the history of the Ozarks through archaeology, geology, and mineralogy. Eclectic items include Thomas Hart Benton and Rose O'Neill originals, plus memorabilia from the Ozark Jubilee and *The Beverly Hillbillies*. (Courtesy of Ralph Foster Museum.)

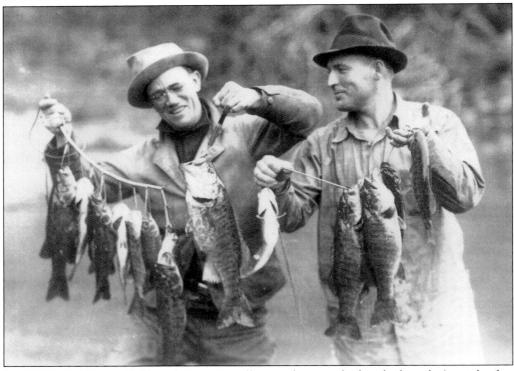

In 1945, Ralph Foster (left) and Dave Parnell were photographed with their day's catch after fishing on Lake Taneycomo. Foster founded the WKTO radio station in Springfield, Missouri, in 1933. He was an avid fisherman, hunter, and longtime collector of Indian artifacts. Foster and Dr. Robert M. Good, president of the School of the Ozarks from 1921 to 1952, were inducted into the Greater Ozarks Hall of Fame in 1976. (Courtesy of BCM.)

In 1940, Jimmie S. Justus posed near the Branson High School, which was completed in 1931. Jimmie worked as an attendant in the Binkley Motor Company garage and lived with his grandmother Myrtle B. Hayes Justus, who ran a Commercial Street boardinghouse. His grandfather John H. Justus died in 1937 after serving over 15 years as the Branson station agent for the Missouri Pacific Railroad. (Courtesy of WRVHS.)

Belle Mosley began teaching public school in Lawrence County, Missouri, in 1917, at the age of 16. She came to teach math and commerce at the Branson High School in 1938. She took on the role of principal when Elmo Ingenthron joined the Navy during World War II. She signed over 1,400 diplomas before retiring in 1967. Mosley became a charter member of the Business and Professional Women's Club in 1941 and later served as an officer of the White River Valley Historical Society. (Courtesy of BCM.)

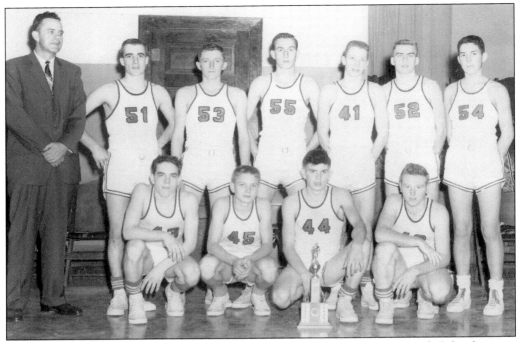

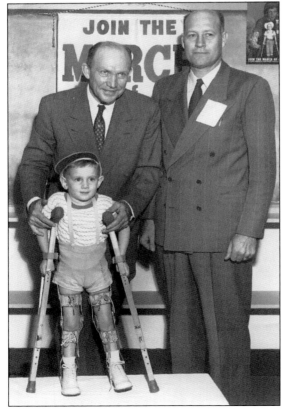

Seen in the Branson High School gymnasium in 1952 are, from left to right, (first row) Bob Parnell, Charles Crosby, Willard Persinger, and Johnny Boyd; (second row) coach John Earl Chase, Harold Meadows, James Pennington, unidentified, Perry Barnes, David Shanahan, and Gene Aubin. Six years later, on February 4, a fire destroyed the gym and several classrooms. Student Beverly Jones was hospitalized, while teacher Virginia Wilcox and superintendent James F. Coday were treated and released. (Courtesy of WRVHS.)

As a result of polio, Pres. Franklin D. Roosevelt became paralyzed below the waist in 1921, which led to his development of the National Foundation for Infantile Paralysis in 1938. Following the elimination of polio, a new name and purpose was adopted: the March of Dimes, for the prevention of birth defects and infant mortality. Branson High School superintendent James F. Coday (right) was photographed with an unidentified man and child in about 1950, during the annual fund drive. (Courtesy of WRVHS.)

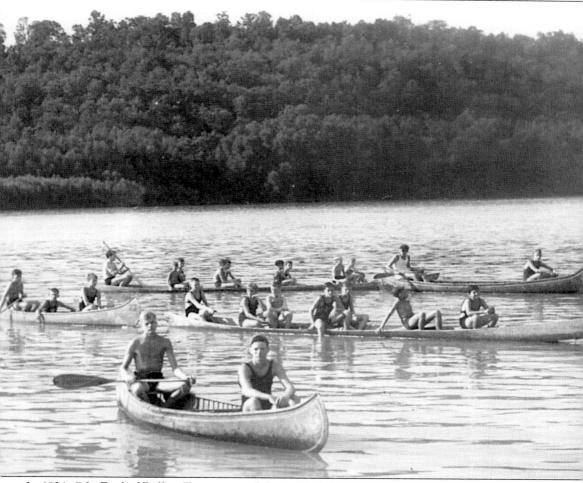

In 1924, C.L. Ford of Dallas, Texas, opened the girls' Kickapoo Kamp on 128 acres, with half a mile of Lake Taneycomo frontage. Housed seven to a cabin, the girls were divided into two Indian tribes, the Cherokees and the Choctaws, each with a chief, medicine man, scribe, and musician. Weekly tribal meetings were held in the woods after dark, and an Indian ceremony was held the last night, with Indian blankets presented to the tribe with the highest number of honor points. The camp was so successful that Ford established the Kuggaho Kamp for boys in 1927. The 1927 season brought 53 girls and 30 boys to camp. Mr. and Mrs. G.H. Regan supervised the Kickapoo Kamp in 1929, while Mr. and Mrs. W.A. Walker of Dallas, Texas, supervised the boys. That year, the K-Kamps' enrollment was so high that a special train brought the Texas campers, and two additional buildings were constructed in the boys' camp. The boys' canoe fleet was photographed in 1931. (Courtesy of Kanakuk Kamps.)

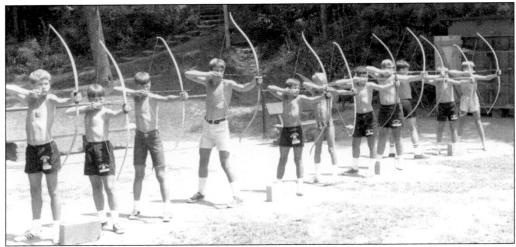

Coach William C. Lantz became director in 1932, changing Kuggaho Kamp to Kanakuk Kamp, which he purchased two years later. In 1935, the *Joplin Globe* reported that 30 parents and 50 boys attended the end-of-season banquet in the camp's mess hall. The campers received merit awards for various camp activities, including archery. The boys were photographed honing their archery skills during the 1950s. (Courtesy of Kanakuk Kamps.)

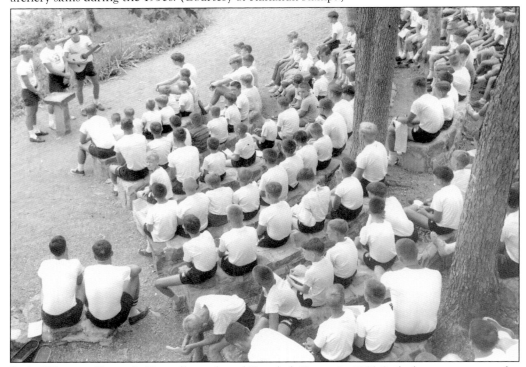

Spike White and his wife, Darnell, purchased Kanakuk Kamps in 1955. Spike began as a counselor in 1931, left briefly, and then returned in 1938. The Whites began a Kanakomo Kamp for girls in 1958. In 1976, their son Joe and his wife, Debbie Jo, purchased Kanakuk Kamps from them. In the 1950s, campers and their counselors were photographed during Sunday church services. (Courtesy of Kanakuk Kamps.)

Three

ROLLING ON THE RIVER

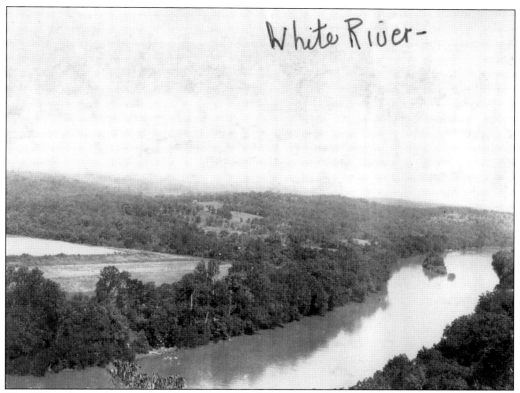

The White River begins as a clear spring in the Boston Mountains, about 50 miles south of Eureka Springs, Arkansas. It flows through Arkansas and then north into Missouri, eventually winding its way across the southern portion of Stone and Taney Counties on its 722-mile trip to the Mississippi River. Native Americans, early explorers, and adventurous pioneers looked to the White River for fresh water and fish, as well as a means of travel. By the mid-1800s, newcomers arrived via the White River. It later became a source of income as the railroads pushed into the territory, requiring large quantities of railroad ties. The logs for these ties and other wood products were floated downstream to Branson, which became a hub for log shipping following the completion of the White River Railway Line in 1906. Springfield bakery owner and amateur photographer Domino Danzero shot this photograph from across the White River on Presbyterian Hill in about 1910. (Courtesy of MSU.)

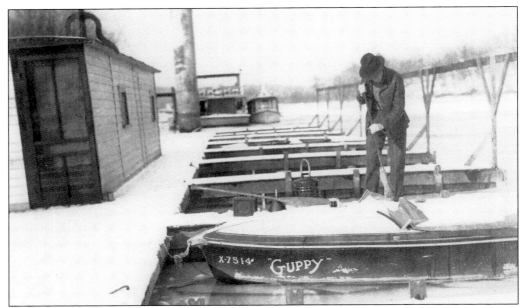

Around 1900, Charlie (above), Herb, and John Barnes of Galena, Missouri, established the region's first commercial float-fishing operation. They took customers down the James River from Galena to where it flows into the White River, not far from Branson. The 125-mile trip took five days. Charlie (below) charged $2 per person per trip for the use of the boats he had built himself. Each guide cost $1.50 per day. When the float trip ended, Charlie arranged to have the boats hauled back from Branson to Galena on Missouri Pacific Railroad flatcars. Later, trucks with trailers hauled the johnboats, equipment, and clients back to Galena. In 1911, the *Springfield Missouri Republican* reported camping parties coming hundreds of miles from other states to hunt and fish on the Barnes float trips. (Above, courtesy of BCM; below, courtesy of WRVHS.)

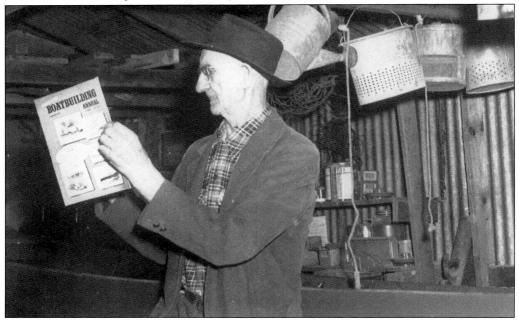

In 1932, Charlie Barnes moved to Branson, where he later built johnboats for Jim Owen. After arriving in Branson in 1933, Owen opened a theater, began a float-fishing business, and became a banker and a farmer, as well as Branson's mayor. Ralph Foster (right), originator of Springfield's KWTO radio station and the Ozark Jubilee, is pictured with an unidentified buddy following an Owen Boat Line float trip. (Courtesy of WRVHS.)

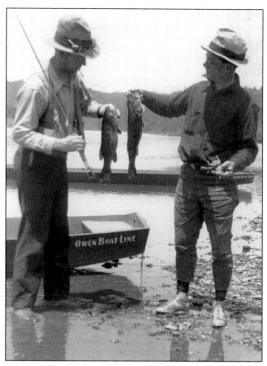

Sitting under a "Fisherman's Corner Liar's Club" sign about 1945 are, from left to right, "Toots" Spencer, actor Smiley Burnette, Jim Owen, Judy Miller, and her parents, Nadine and Steve Miller. In the 1930s, Burnette began his career as a country music performer and Gene Autry's comedic sidekick. During the next two decades, he lived part-time in Springfield, Missouri, often visiting Branson. In the 1960s, Burnette was a *Petticoat Junction* regular. (Courtesy of BCM.)

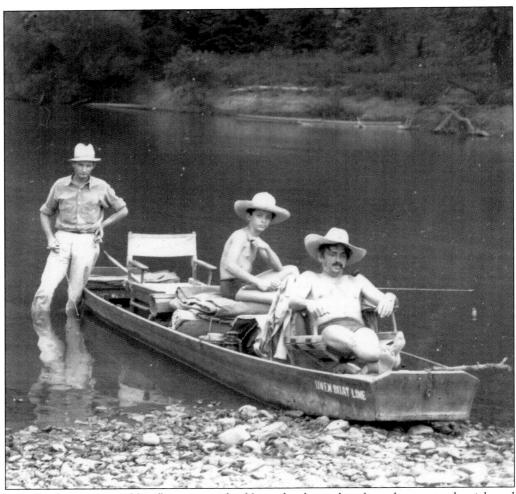

Initially, Jim Owen paid his float trip guides $3 per day, but as his clientele grew to the rich and famous, he increased his wages to $10 per day. By 1955, Jim Owen's daily float trip rate was $22 per person. Celebrity floaters included Thomas Hart Benton, Forrest Tucker, Charlton Heston, Smiley Burnette, and Gene Autry (who reportedly fell out of a boat). A marketing genius, Owen eventually owned 40 boats and employed 35 guides, including the Barnes brothers. In the early 1940s, painter and muralist Thomas Hart Benton shared an Owen Boat Line johnboat with his son Thomas Piacenza Benton and an unidentified float trip guide. Benton often portrayed the White River in his paintings. Benton's grandson, Anthony Benton Gude, carries on his grandfather's tradition of depicting the Midwest on canvas and in murals. (Courtesy of Ralph Foster Museum.)

In 1977, "Big Jim" Owen was inducted into the Greater Ozarks Hall of Fame of the Ralph Foster Museum at the School of the Ozarks. Owen was in good company; fellow inductees included Dr. M. Graham Clark, former School of the Ozarks president, and author Laura Ingalls Wilder. The wooden plaques were provided by the late Peter Engler, a nationally known master woodcarver of Branson. (Courtesy of Jim Owen.)

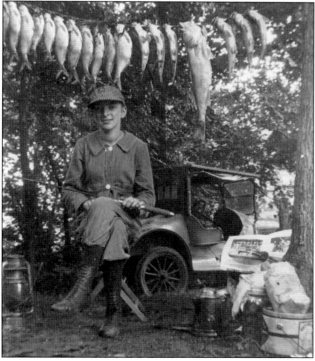

By 1911, Missouri governor Herbert S. Hadley had pushed to dam the White River, which he considered one of the Ozarks' most valuable assets. Hadley planned to utilize the wasted waterpower to furnish electrical power and light to Springfield, Joplin, and Branson. The reservoir formed by the dam provided an excellent home for Missouri's finest game fish. Leola Danzero poses with the day's catch in about 1922. (Courtesy of WRVHS.)

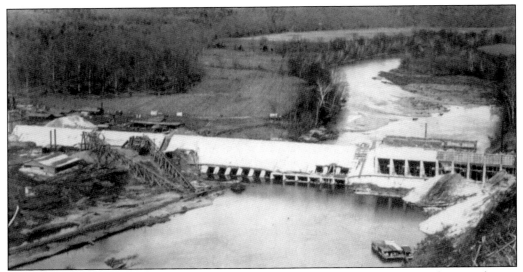

In 1911, the Ambursen Hydraulic Construction Company of Boston, Massachusetts, began constructing a power-generating dam upstream from Forsyth, Missouri. Built for the Ozark Power and Water Company, it was named the Ozark Beach Dam but called the White River Dam; it is now known as the Powersite Dam. With his patented design, company founder Nils F. Ambursen, a Norwegian American civil engineer, constructed more than 100 dams between 1903 and 1917. (Courtesy of MSU.)

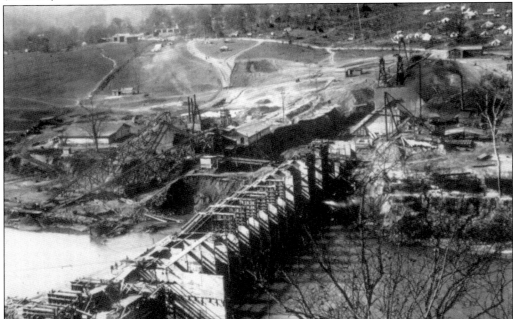

About 250 yards above the dam site, Camp Ozark developed on the former homestead of the Oliver family. Once the land had been cleared, tents, bunkhouses, cottages, a kitchen and dining hall, and a store were built. Benjamin "Albert" Parnell Sr. ran the commissary in 1912. With transportation difficult, most workers lived on-site, and many brought their families. The camp population swelled to 1,000, which included more than 40 children. (Courtesy of MSU.)

Between 1911 and 1913, more than 1,000 men were employed to construct Missouri's first hydroelectric dam. The nearly $1,500-per-day payroll for daily laborers accounted for the majority of the $2.3-million construction cost. More than 50 wagon teams were used to haul materials and supplies from the railroad at Branson to the dam site. Camp Ozark's permanent structures later became part of Ozark Beach. (Courtesy of MSU.)

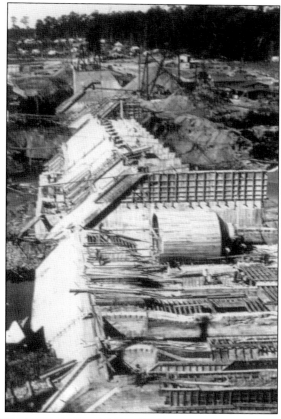

On May 10, 1913, Ozark Beach Dam closed for the first time. Within 30 hours, Lake Taneycomo, named for Taney County, Missouri, reached its natural depth. The newly formed 22-mile-long lake encompassed 2,080 acres. Even at 50 feet high and 1,200 feet wide, the dam failed to tame the White River. Flooding still occurred, causing devastation among local communities. Completed in 1958, the Table Rock Dam controlled flooding until 2008. (Courtesy of MSU.)

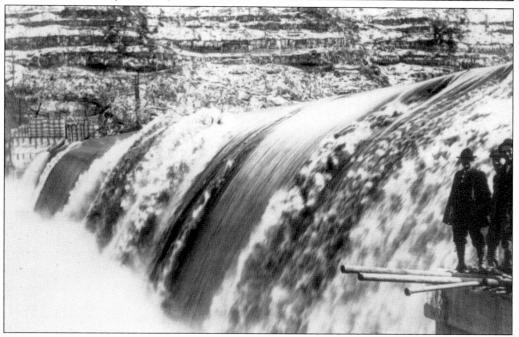

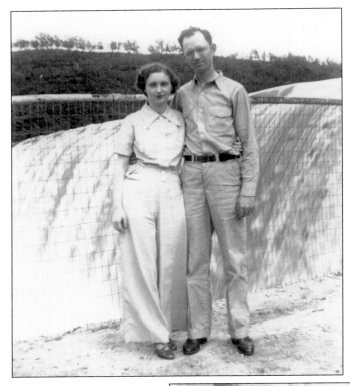

The impoundment of the White River created warm waters, which lured tourists to what early promoters had dubbed "the Land of a Million Smiles." Byron and Ella Mae Maupin Tucker are seen posing at the Powersite Dam in 1938. During the 1940s, Ella wrote several columns for the *Springfield News & Leader*, and during the 1960s, the Tuckers ran a photography and print shop in Silver Dollar City. (Courtesy of Irene Maupin Johnson.)

In 1913, the Missouri Pacific Mountain Railroad offered daily round-trip fishing excursions from Springfield to Branson at a rate of $2.60. That July, Branson businessman Henry Sullinger pulled in a 4.5-foot catfish that his steel motorboat propeller had struck. It tipped the scales at 75 pounds! A few years later, Domino Danzero (fourth from the left) posed with unidentified men as he displayed the flathead catfish he caught, which also weighed about 75 pounds. (Courtesy of MSU.)

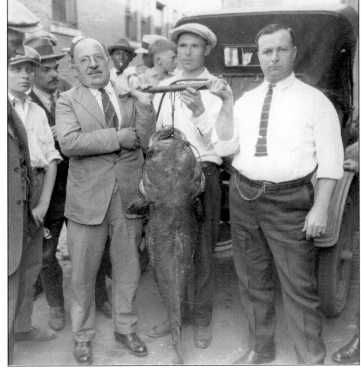

According to the *Springfield Missouri Republican*, all hotels and camps along Lake Taneycomo were full to overflowing by the summer of 1915, and private residents even took in roomers. Teeming with bass and crappie, Lake Taneycomo drew flocks of avid sportsmen for its renowned black bass. Displaying a fine catch is "Uncle" Moses Ratcliff Whelchel, father of Ratcliff Oscar Whelchel, owner of the Whelchel Funeral Chapel in Branson. (Courtesy of BCM.)

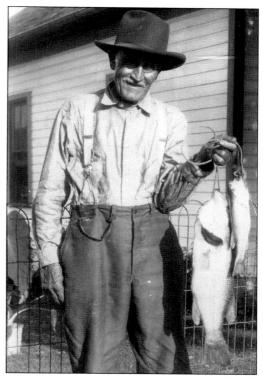

In 1926, Remel "Red" Haskett of Branson practiced diving at Springfield's Doling Park. The next year, 16-year-old Haskett swam Lake Taneycomo for nearly 10 hours during the 20-mile marathon of the Branson Water Carnival. Haskett won $500 in prize money, which he earmarked for his education. Unfortunately, marathon promoter Gene Clark neglected to pay the winnings. Injured in an automobile accident while fleeing Branson, Clark was arrested in a Springfield hospital. (Courtesy of MSU.)

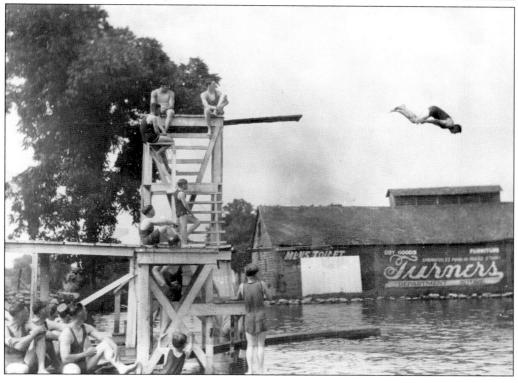

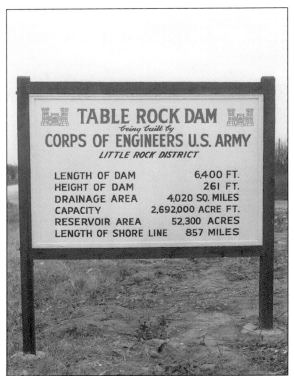

In 1911, a House bill authorized the City of Hollister to build a White River dam. In 1924, the first machinery and drills arrived in Branson for river bottom testing to begin. In the Flood Control Act of 1941, Congress authorized the construction of the Table Rock Dam. Unfortunately, World War II and the Korean War delayed construction. In 1946, the White River Valley Flood Control Association once again promoted the project. In October 1952, nearly 2,500 attended the Table Rock Dam groundbreaking. Lifting ceremonial shovels are, from left to right, Orval Faubus, Arkansas Highway Commission chairman; O.D. Lee, Branson Chamber of Commerce president; James Trimble, Arkansas congressman; Lt. Gen. Lewis A. Pick, chief of engineers; Dewey Short, Missouri congressman; and Dr. Graham Clark, School of the Ozarks president. (Left, courtesy of MoDOT; below, courtesy of Ralph Foster Museum.)

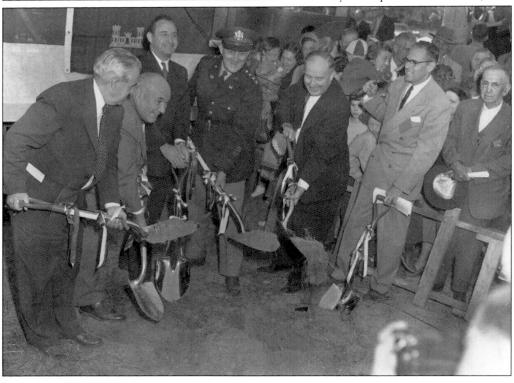

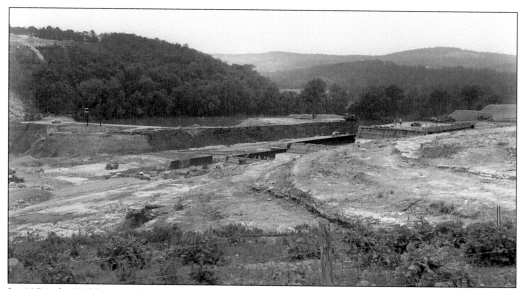

In 1954, the Table Rock Dam moved closer to reality when the Morrison-Knudsen Company of Idaho and the Utah Construction Company of California jointly submitted the low bid of just under $25 million. They began work in October of that year. Much of the area in the photograph is now under Table Rock Lake, which is the second-largest body of water in Missouri. (Courtesy of Lucile Morris Upton.)

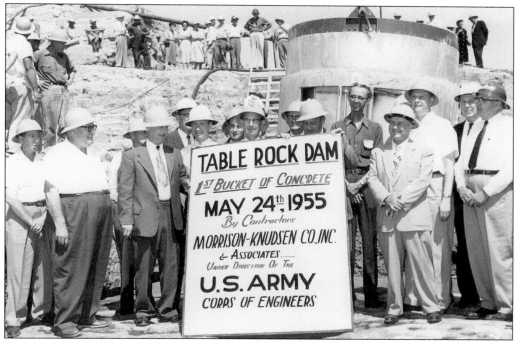

On May 24, 1955, a short ceremony accompanied the pouring of the first bucket of concrete for the Table Rock Dam. Present are Col. Staunton Brown, Little Rock district engineer; Lincoln F. Sherman, Corps of Engineers project engineer; Roger Evans, Morrison-Knudsen Construction Company project manager; Dewey Short, congressman; and several unidentified spectators. (Courtesy of BCM.)

The Baird Mountain Quarry, south of the Table Rock Dam in western Taney County, produced every type of aggregate the dam required. Crushed rocks were moved on a 6,000-foot conveyor to the plant, perched high on a bluff overlooking the dam. The processing plant produced 375 tons per hour of top-grade sand and stone, which met the demand for 15,000 yards of concrete per week required for the dam construction. (Courtesy of BCM.)

The Lyle Davidson House Moving Company relocated homes that would have been covered by Table Rock Lake, which formed when the Table Rock Dam closed. The graves and headstones of Joseph Philibert, his wife Peninah Yoachum Philibert, and their son Charles Edward Philibert were relocated, along with 19 others. In 1833, Philibert married the 16-year-old daughter of Jacob Yoachum, famous for the Yoachum "Silver Dollars" and their lost silver mine. (Courtesy of BCM.)

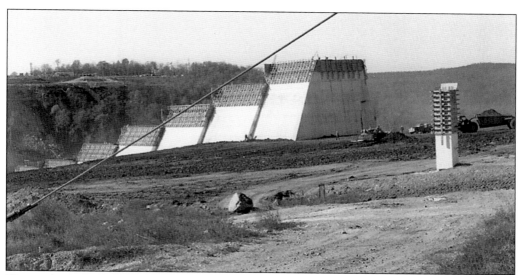

Shown during construction in October 1955, the Table Rock Dam is 6,423 feet long, with a concrete section measuring 1,602 feet long, which contains 1.23 million cubic yards of concrete. There are 3.32 million cubic yards of concrete in two earthen embankments. The dam rises 252 feet above the riverbed. Once closed, the dam created Table Rock Lake, covering over 43,000 acres with about 850 miles of shoreline. (Courtesy of Lucile Morris Upton.)

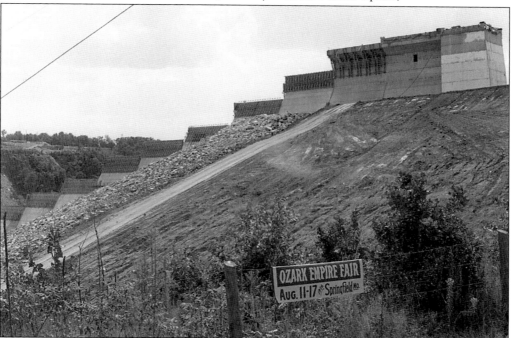

This photograph of the Table Rock Dam was taken in 1956. Hanging on the chain-link fence is an advertisement for the Ozark Empire Fair, held August 11–17, 1956, in Springfield, Missouri. Once completed, four 18-foot-diameter penstocks would convey water to four 50,000-kilowatt generators in the powerhouse. The first two units were ready to generate power in June 1959, and the last two units were installed by August 1961. (Courtesy of Lucile Morris Upton.)

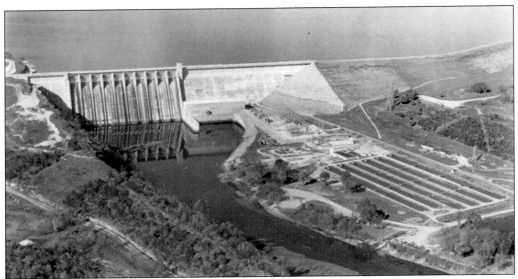

Completion of the Table Rock Dam permanently altered Lake Taneycomo. Table Rock Lake was deeper and larger, causing much colder water to flow into Lake Taneycomo, thus its temperature dropped significantly. Too uncomfortable for swimming, the lake's tourism declined at the Rockaway Beach resorts. Now, the US Army Corps of Engineers maintains 14 campgrounds (including one in Arkansas) and leases 15 commercial marinas, which generate annual revenue of over $36 million. (Author's collection.)

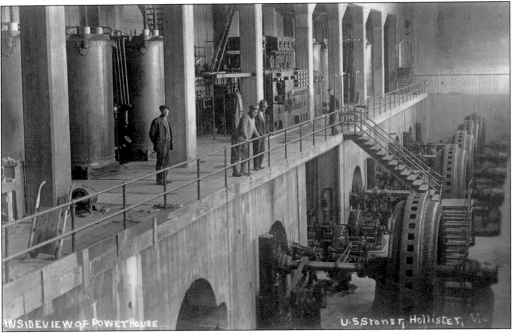

Hydroelectric power is produced as water passes through the dam and into the river below. The falling water spins the magnets of the turbine, and when the magnets spin over its metal coils, electricity is produced. Dams provide clean, pollution-free energy. The interior of the Table Rock Dam powerhouse is shown after completion in 1958. (Courtesy of Springfield Museum on the Square.)

Four

GETTING AROUND THE OZARKS

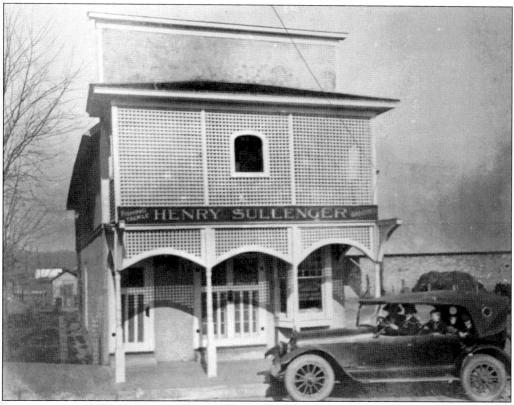

As owner of one of the first automobiles in Branson, James "Henry" Sullinger is seated in his 1920s vehicle with his wife, Mayme D., and their three oldest children, Karl, James, and Edna. Their youngest son, Joe Henry, was born in 1927. Mayme was the daughter of Solomon and Malinda B. Parnell Linzy. Sullinger (alternately spelled "Sullenger") owned the first business in Branson. It began as a saloon, pool hall, and boardinghouse catering to the railroad workers, then later became a fishing tackle and grocery store. Prior to 1909, Sullinger and fellow business owners relocated their businesses from Third and College Streets when Main Street became the new commercial district. The Henry Sullenger store relocated to the northwest corner of Sycamore and Main Streets. Currently, this is the oldest freestanding building in Branson and one of few buildings to survive the 1912 fire. (Courtesy of BCM.)

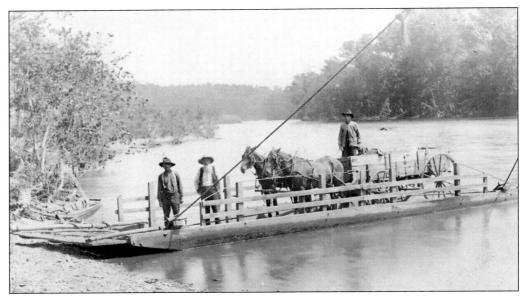

Licensed ferry operator Henry H. Compton (left) and his wife, Annie E. Compton, owned Compton Ferry at the mouth of Roark Creek. Baptist preacher Harrison Collins (center) and his son William Harrison Collins (right), the Christian Union Church preacher, were photographed in 1909. When the Powersite Dam created Lake Taneycomo in 1913, White River ferry service became obsolete, as new bridges and roads were built to accommodate tourists and residents. (Courtesy of BCM.)

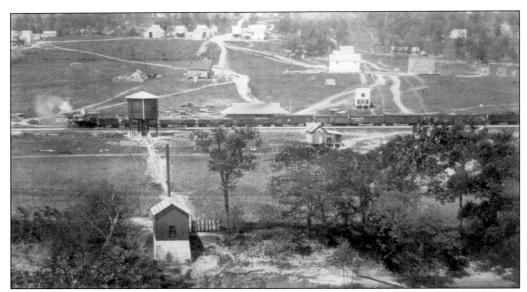

The Missouri Pacific Railroad (MoPac) train is shown passing through Branson in early 1908. Known as the "First Railroad of the West," the MoPac completed the White River Line track through the Roark Valley in 1906, opening the Branson area to tourism. Thousands of workers spent four years laying 239 miles of track through the steep hills and deep valleys at a cost of $12 million. (Courtesy of BCM.)

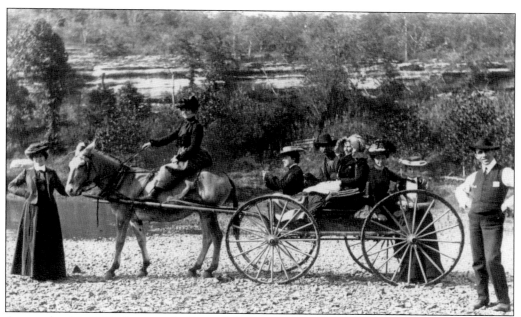

As seen by this 1908 photograph, Springfield bakery owner and photographer Domino Danzero and the unidentified members of his family dressed quite fashionably to visit Branson's White River area. The woman at center in the carriage is attired in a curtain bonnet with a back ruffle called a *bavolet*, which shaded the neck. Two of the ladies are wearing straw boaters with stiff brims and a ribbon band, while the others are sporting elaborate hats in the style of the day. (Courtesy of MSU.)

An unidentified couple poses along an Ozarks mountainside in about 1915. The woman beside the automobile wore her fur coat, pointed-toe shoes, and a calf-length skirt. The shorter skirt was a result of both practicality and wartime deficits. During World War I, more than 1.6 million women worked in government positions alone, thus they required garments with a wider range of movement than the trendy tight-legged hobble skirts of the prewar period. (Courtesy of MSU.)

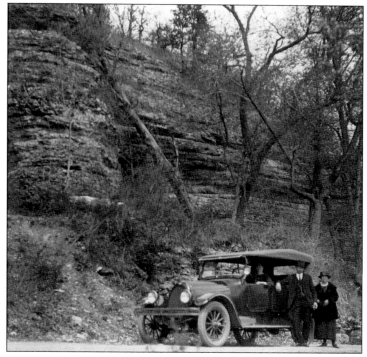

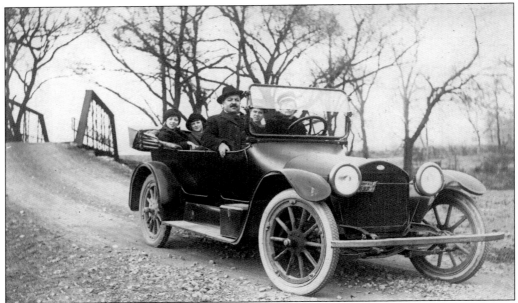

In 1915, the Danzero family returned to Branson in their Regal Light Four. For less than $700, the Regal Automobile Company offered a 106-inch wheelbase, a long-stroke 27-horsepower motor, a five-passenger streamlined body, and an electric horn, along with a lighting and starting system. Manufactured in Detroit (near the first Ford Motor Company factory), a Light Four was said to cost less to maintain than a team of horses. (Courtesy of MSU.)

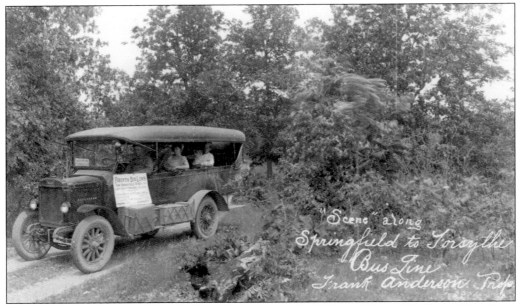

After the completion of the Powersite Dam in 1913, Frank Anderson began his Forsyth Bus Line. Shown driving unidentified passengers in his modified Nash truck, Anderson hauled visitors to Forsyth, Branson, and Lake Taneycomo. He would depart Springfield at 8:00 a.m. from his office in the Firestone Agency at the corner of McDaniel Street and Jefferson Avenue and return at 5:00 p.m. One-way tickets cost $3.75, with round-trip tickets at $7.50. (Courtesy of SGCLD.)

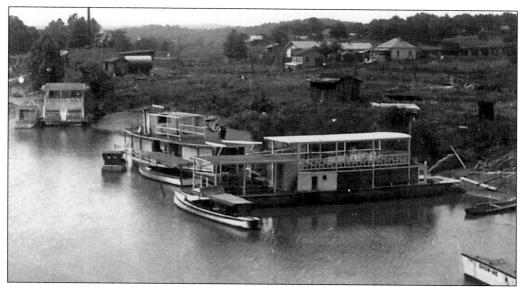

In August 1913, the annual report of the Missouri Division of Industrial Inspection and Bureau of Labor Statistics hailed Lake Taneycomo as "the Niagara of the Ozarks," claiming it was "the largest body of fresh water between the Great Lakes and the Arkansas Line . . . with over 50 motorboats, steamers, and launches plying people back and forth on the lake." A shipyard was located between Hollister and Branson, where boats were constantly being built. Many were made entirely from local materials, while others were shipped in from area factories. The first excursion boats were launched in 1913. The *Virginia May*, the *Show-Me*, and two others (above) are shown docked near the Main Street Bridge in 1913. The *Sadie H.* (below) was photographed in 1928. (Above, courtesy of BCM; below, author's collection.)

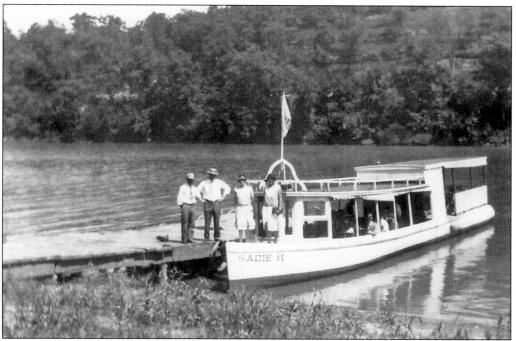

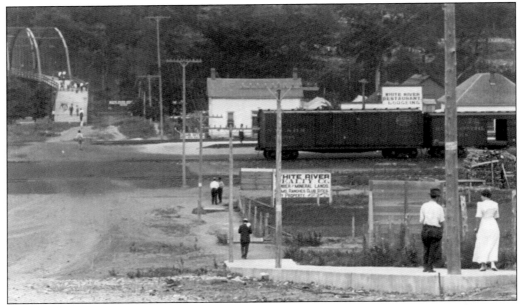

This 1916 photograph provides an eastward view of Main Street to the Main Street Bridge, across Lake Taneycomo. Begun in 1904 by J.W. Heyford, Walter J. Moore, and C.M. Thompson, the White River Realty Company advertised timber, mineral lands, farms, ranches, club sites, and city properties for sale. Just past the railroad crossing was another sign advertising the White River Restaurant and lodging. (Courtesy of First Baptist Church of Springfield.)

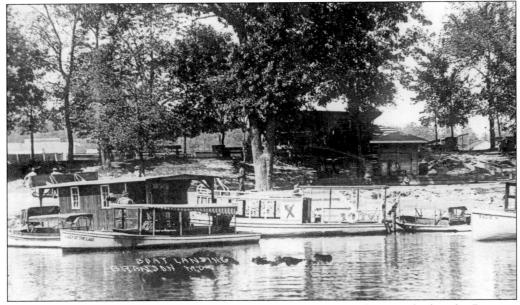

In 1919, the *Lady of the Lake*, the *Sadie H.*, and other boats were photographed at the Branson Boat Landing. Springfield's first female reporter and local historian, Lucile Morris Upton, wrote the following statement on the back of the image: "Boat marked with a cross is the one we went to Powersite Dam in July 27, [1919] Momma [Veda Morris], Uncle G.W. [George Wilson], Etna [Morris], George [Morris], Wilson Gyles and I went." (Courtesy of Lucile Morris Upton.)

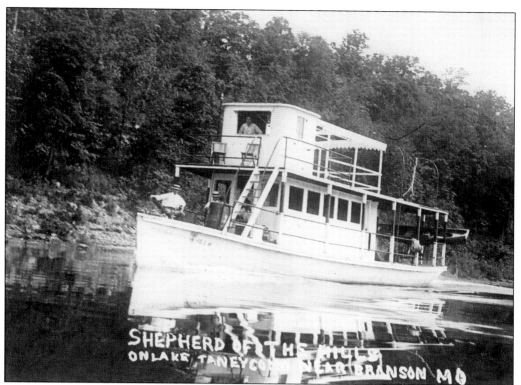

In the late teens and early 1920s, Lucile Morris Upton and her two brothers, Mount Etna "M.E." and George Morris, spent their summers at their cabin on Presbyterian Hill. While on an excursion from Branson to Powersite Dam in July 1919, Upton noted that the *Shepherd of the Hills* tour boat was the largest on Lake Taneycomo during that summer, as it could comfortably carry about 75 passengers. (Courtesy of Lucile Morris Upton.)

About the mid-1920s, these two young women (or perhaps boys) found themselves victims of the poor rural Branson roads. Both "girls" are wearing knickerbockers, or knickers. A form of breeches gathered and banded below the knee, knickerbockers were regarded as the traditional dress of Dutch settlers in America. Popular for men and boys in the early 20th century, girls and women had popularized them by the mid-1920s. (Courtesy of MSU.)

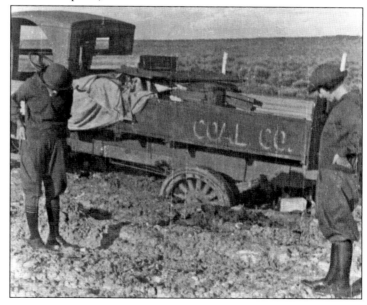

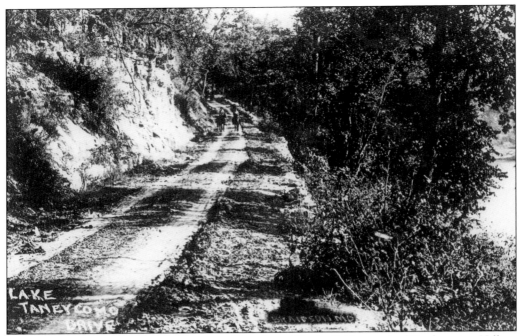

In 1909, the First and Second Presbyterian Churches of Springfield organized Presbyterian Hill on a bluff overlooking Branson in Hollister, Missouri. Initially, Presbyterians could enjoy three-week summer getaways, but by the 1920s, the site had been converted to a year-round facility. This 1919 postcard shows two men riding horseback along Lake Taneycomo Drive (now Lakeshore Drive), which was the route taken into Branson from Presbyterian Hill. (Courtesy of Lucile Morris Upton.)

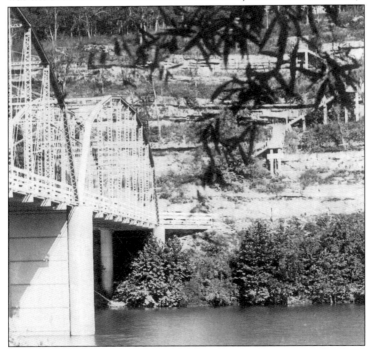

About 1920, Branson's Main Street Bridge over Lake Taneycomo was photographed. Seven years later, the approach to the bridge washed away during flooding. The two-span through-truss bridge was condemned in 1943, following another flood that damaged its middle pier. Two years later, another flood destroyed the bridge. Steps to Presbyterian Hill from the old bridge can be seen in the background. (Courtesy of WRVHS.)

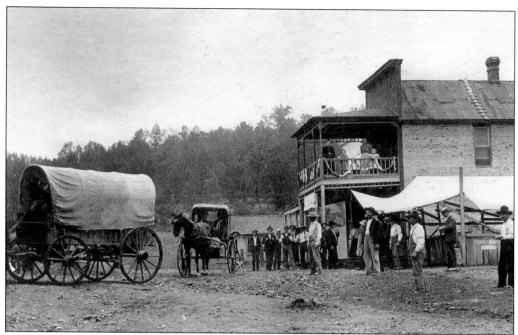

Horses, covered wagons, carriages, and carts were common forms of transportation throughout the Ozarks until the early 1920s, when automobiles became more widespread. Shown in Branson around 1900 is a covered wagon and a two-wheeled, one-horse-drawn vehicle designed for two people called a "gig." Today, trail rides on horseback through the historic hills are an enjoyable way to view rural Branson. (Courtesy of MSU.)

Automobiles began appearing in Branson by 1913, but their sightings were rare. By the mid-1920s, over $34,000 was spent yearly creating, maintaining, and improving Taney County's roads and bridges, which would now be over $450,000 per year. The one-lane Main Street Bridge was originally built for wagon use. Remote roads were still neglected, and wet-water creeks, which formed in dry creekbeds during periods of heavy rain, posed a danger to motorists driving off the beaten path. (Courtesy of BCM.)

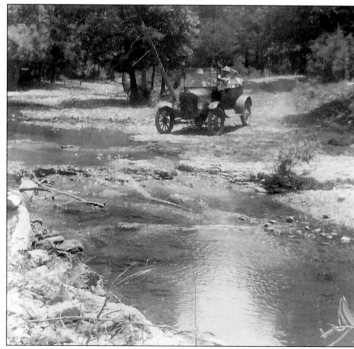

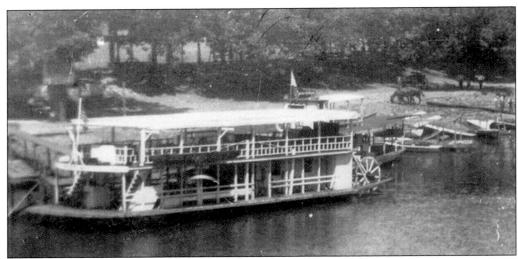

In the summer of 1920, a group of unidentified students from the School of the Ozarks (now College of the Ozarks) traveled aboard the excursion boat *Virginia May* from Branson to the Powersite Dam. On the back of these photographs, they detailed their route on the White River to the White River Dam. Actually, on May 9, 1913, the gates of the Powersite Dam were closed for the first time, and the free-flowing White River became a warm-water lake in less than two days. Lake Taneycomo was named after its location in Taney County, Missouri. Above, the *Virginia May* is docked at the Branson Boat Landing, and below, the students are disembarking from the *Virginia May* in Branson. (Both, courtesy of Gerry Chudleigh.)

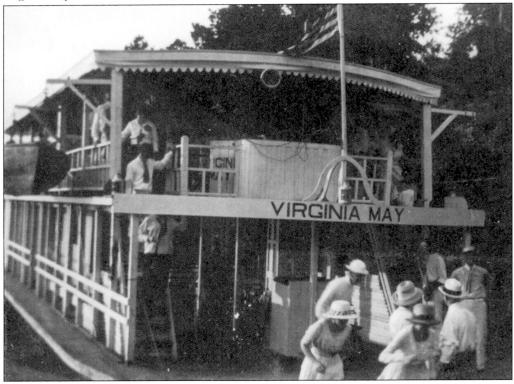

In August 1923, the unidentified students from School of the Ozarks (now College of the Ozarks) returned to Branson for another trip. They photographed the captain of the *Shepherd of the Hills* excursion boat (right) while docked at the Branson Boat Landing. The *Shepherd of the Hills* was the pride of the Sammy Lane Boat Line, begun by boatbuilders Hobart G. McQuerter and Charles M. Givauden after the creation of Lake Taneycomo in 1913. The *Shepherd of the Hills*, along with the *Sammy Lane* and the *Jim Lane*, carried mail, freight, and passengers between Branson and neighboring cities, in addition to conducting special dance tours. The students traveled to the White River Dam (known as Powersite Dam) aboard the *Joseph H.* tour boat, pictured below. (Both, courtesy of Gerry Chudleigh.)

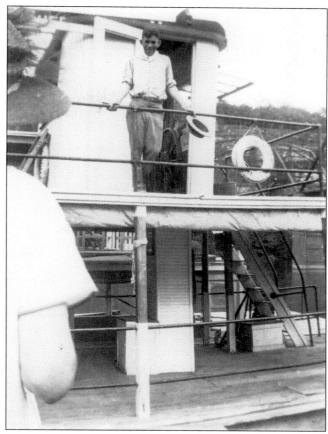

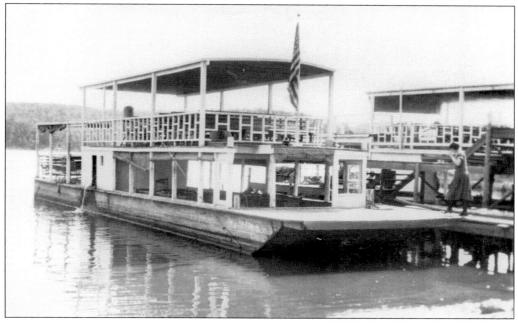

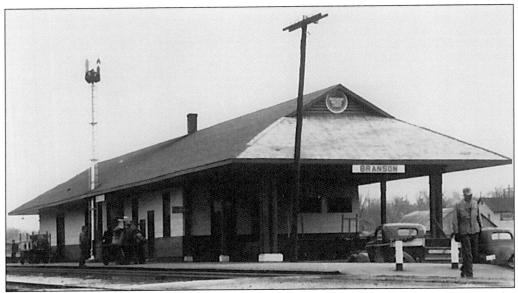

In 1882, Reuben S. Branson was granted a post office on Bull Creek. The following year, he relocated his Branson Post Office upriver to the confluence of Roark Creek and the White River. In 1884, Branson sold out to William W. Hawkins, Branson's second postmaster. Hawkins was still postmaster when the name changed to Lucia on May 2, 1901, for the small town developing there. Lucia's official town plat was filed on October 2, 1903. Meanwhile, the Branson Town Company developed land north of Lucia, filing Branson's town plat 24 days later. Within two years, the White River Railway brought tourists to Branson's new depot (above). Lucia landowners quickly sold out to the Branson Town Company. The Lucia Post Office was renamed the Branson Post Office in 1904. The City of Branson was officially chartered on April 1, 1912. Unidentified employees were photographed inside the Branson depot in May 1927. (Both, courtesy of BCM.)

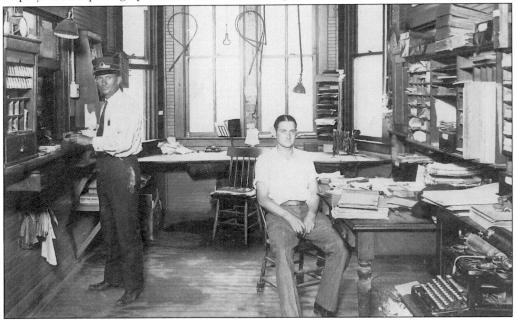

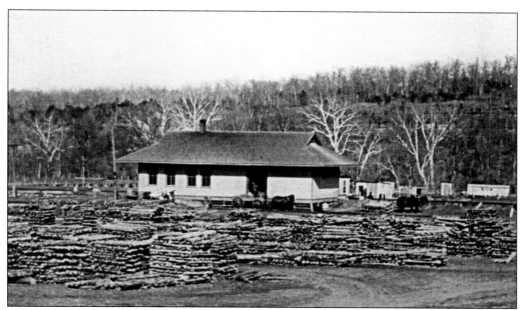

In the early 1900s, the forests of the Ozarks yielded an endless supply of wood to meet the incoming railroad's need for crossties. Farmers left their land for their first cash-paying jobs; a backbreaking day of work earned them 40¢ to 50¢ per tie. Located next to the Branson depot was J.A. Burnett's Burnett Tie Yards, seen full of crossties in 1912. (Courtesy of WRVHS.)

This pre-1916 view shows Highway 3, which was the primary north-south route through Taney County. The highway crossed the Roark Creek Bridge (barely visible in the background) and then ran south into the heart of Branson. It turned east at the intersection of Main and Commercial Streets, continuing to Lake Taneycomo, then crossing over the Main Street Bridge. Eventually, it became US 65. (Courtesy of BCM.)

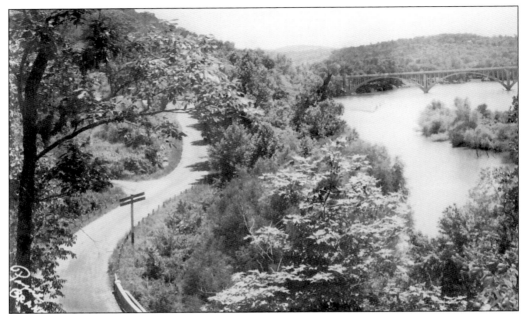

After the Powersite Dam had been completed, the Empire District Electric Company of Joplin, Missouri, bridged Coon Creek for the convenience of the Branson and Hollister residents. Upon completion, it turned the bridge over to the Branson Special Road District. By 1923, the Missouri Highway Department had adopted the Coon Creek Bridge. It replaced the dilapidated steel bridge with a concrete structure. At that time, Branson's eastern city limit bordered Coon Creek, and Hollister's city limit came to the west bank. Neither town claimed the bridge, so it fell into disrepair. Shown above in about 1940 is Lakeshore Drive, heading from the Coon Creek Bridge to the Lake Taneycomo Bridge, a five-span open-spandrel arch bridge built by Fred Luttjohann of Topeka, Kansas, in 1931. MoDOT refurbished the Coon Creek Bridge again in 1945, as seen below. (Above, courtesy of BCM; below, courtesy of MoDOT.)

Five

TAKING CARE OF BUSINESS

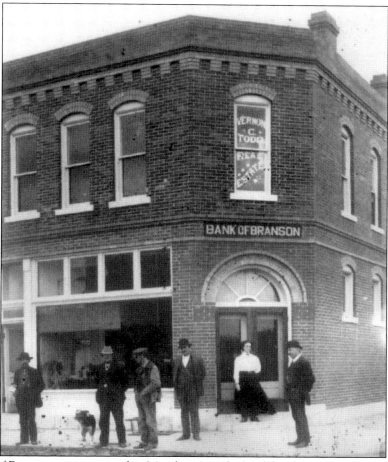

The Bank of Branson was organized in March 1906. The brick bank building was constructed at the corner of Main and Commercial Streets at a cost of $3,463, plus $1,600 for the furniture and fixtures. James G. Root, Andrew J. Brazeal (the former Taney County tax collector from 1902 to 1906), and William H. Crowder served as bank directors. Local cattleman Jesse William Oliver served as president. Oliver was the great-grandson of James Oliver, who settled in Taney County in 1831 and served as a Taney County judge from 1837 to 1844 and 1882 to 1884. Oliver owned probably the oldest water-powered mill in Taney County. Acting as cashier was Jesse A. Tollerton. In 1909, Tollerton sold his interest in the Bank of Branson to serve as the fish and game warden out of Springfield. In the 1920s, Tollerton managed Pierce Oil Company in Greene County. Real estate developer Vernon C. Todd organized the Bank of Branson with Crowder. From the offices above the bank, Todd owned and managed a boating company and lumberyard, in addition to his instrumental part in establishing the Maine Club. (Courtesy of BCM.)

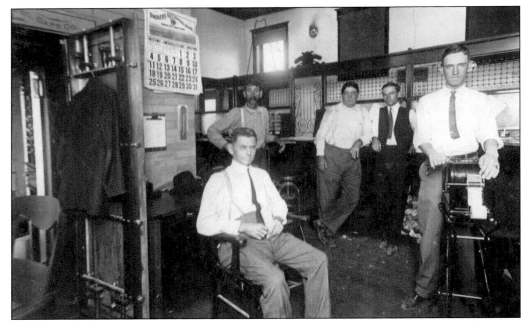

In October 1914, William Hezekiah Crowder (seated) was photographed inside the Bank of Branson with, from left to right, (standing) Frank Long, Jesse W. Oliver, Dave Parnell, and Albert Blansit. Influential in the development of Branson, Crowder helped with the organization of the Bank of Branson in 1906. Crowder began as bank director, then worked as cashier for several years, and later became bank vice president for two years. (Courtesy of BCM.)

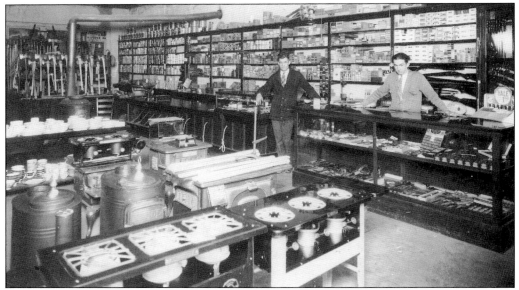

Mount Etna Morris (left) and his son Albert G. Morris are shown in their Morris Hardware Store in Branson in 1890. Albert married in 1896, and they all relocated to Dadeville, Missouri. Albert's daughter Lucile Morris Upton authored *Bald Knobbers*, published by Caxton Printers in 1939. The Morris Hardware Store building became the Western Auto Variety Store in 1989. (Courtesy of Lucile Morris Upton.)

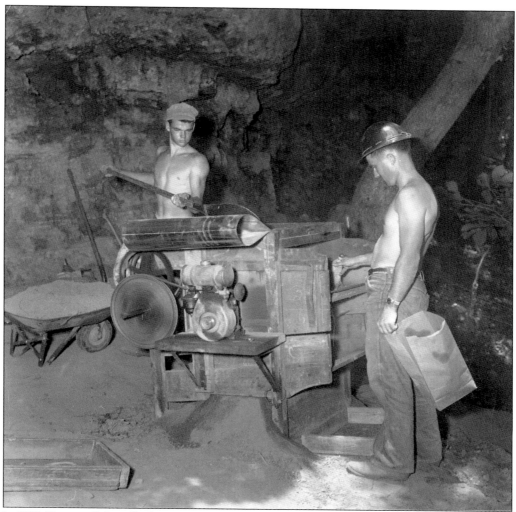

In 1883, Truman S. Powell of Lamar, Missouri, formed the Marble Cave Mining and Manufacturing Company. Lead mining magnate Henry T. Blow of St. Louis had explored the "Devil's Den" 24 years earlier, declaring the cave contained marble. It was renamed Marble Cave, and this misnomer stuck despite geologists ascertaining there was no marble. Bat guano, however, filled the cave 25 feet deep at a value of $700 per ton. Ore carts, donkeys, buckets, and men were lowered into the cave, and pulley systems hauled out buckets of guano for manufacture as gunpowder and fertilizer. The mining company exhausted the cave's "black gold" and closed after less than five years. Left behind was the mining town of Marble City, with its hotel, school, general store, and a few businesses. Renamed Marmaros, which is Greek for "marble," it became a stagecoach stop between Springfield and Berryville, Arkansas. In 1893, the Lynch family purchased Marble Cave and began giving cave tours. Two unidentified young men are shown in a more recent mining operation in the Ozarks. (Courtesy of WRVHS.)

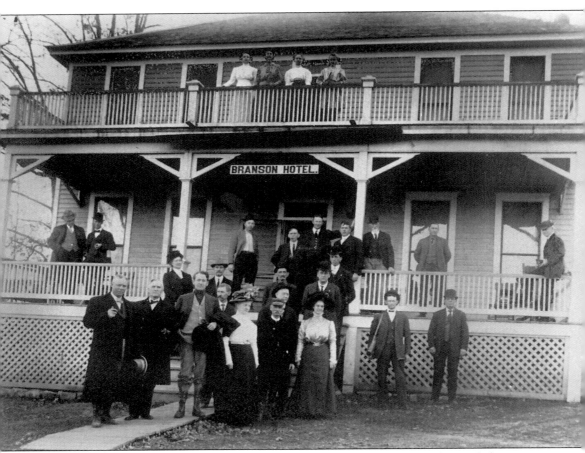

In 1905, proprietor Benjamin Edminster advertised his City Meat Market and the opening of his new Branson Hotel on Main Street. In 1908, James H. and Minnie M. Bramer offered accommodations for $2 per night at their newly acquired Branson Hotel. On October 19, 1910, ex-Missouri governor Joseph W. Folk delivered a campaign speech in Branson during his bid for the 1912 Democratic presidential nomination. Folk was photographed (first row, second from left) at the Branson Hotel, along with Charles Groom, Missouri governor Herbert S. Hadley (1909–1913), Walter Moore, Jesse W. Oliver, Vernon C. Todd, Hobart G. McQuerter, and Missouri game warden Jesse Tollerton. On the upper balcony are, from left to right, Orpha Cottrell, an unidentified hotel cook, Minnie M. Bramer, and another unidentified woman. During the 1920s, waitresses in the dining room earned $1 per day, plus tips, along with two free meals. A new kitchen was added in the 1930s. By the 1940s, the balcony that ran across the top of the front porch had been removed. (Courtesy of WRVHS.)

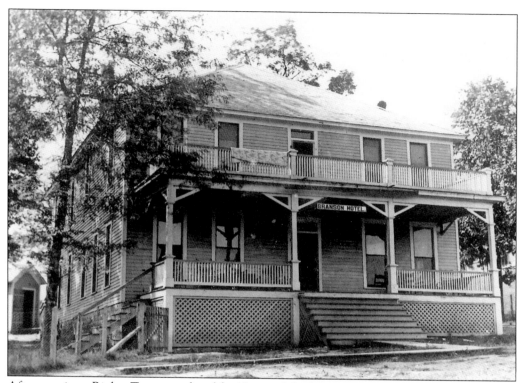

After running a Ripley, Tennessee, hotel for 10 years, John J. Patton and his wife, Laura Ellen "Ella" Lewis Patton, relocated to Branson with two of their four daughters, Edna and Mildred, about 1911. The same year, Charles H. Holman came from St. Louis to work on the Powersite Dam. In 1912, Charles married Mildred. Edna married George B. Hamilton of Forsyth in 1913, then died seven years later. The Pattons had become Branson Hotel landlords by 1920, establishing themselves as owners before the 1930 US Census. The above photograph of the Branson Hotel was taken about 1933. Laura passed away three years later, and John followed in 1938. By the 1940s, a stone wall fronted the property, and the porch pillars were wrapped with stone, as seen below. T.J. and Marie Stottle owned the hotel from 1952 through 1979. (Both, courtesy of WRVHS.)

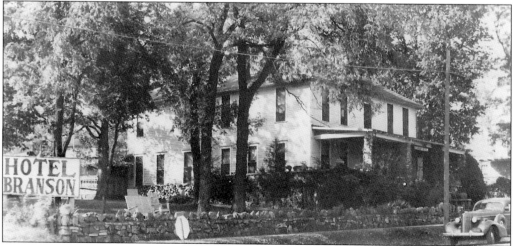

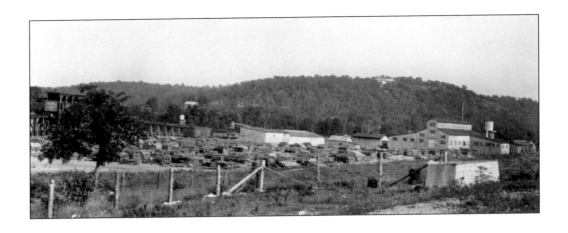

In January 1910, the Branson Town Company donated 700 feet of railroad frontage to the American Lead Pencil Company of New York. Unsuitable for railroad ties, cedar logs made great pencils. Above, thousands of cedar logs were cut into three-by-three-by-eight-inch slats, then shipped as far away as Austria and Germany, where the lead pencils were produced. The outbreak of World War I limited the European market, so production shut down for over a year. The Branson pencil factory reopened in 1915 with a more diverse product line. The cedar was repurposed into linings for cedar chests and "old-fashioned" cedar buckets, which had gone out of vogue following the introduction of galvanized ironware buckets. Shown below in 1913 are young pencil factory workers. Children were considered cheap, manageable labor. (Above, courtesy of First Baptist Church of Springfield; below, courtesy of MSU.)

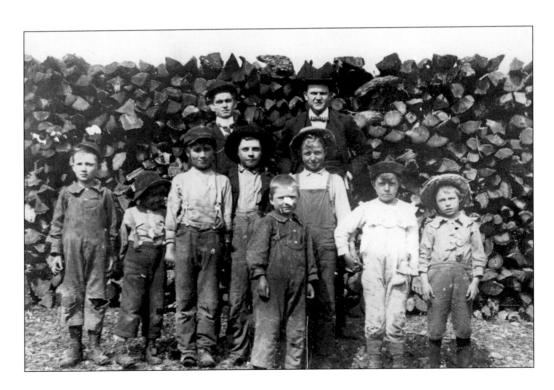

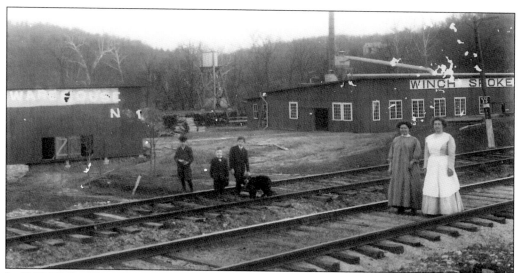

In 1908, Willard E. and Sherman Porter Winch, along with E.W. Hall, incorporated Winch Spoke Company with $20,000, which equals $515,000 today. The Winch Spoke Company supplied three railcar loads of wagon and carriage spokes for the Springfield Wagon Company on a weekly basis. Sherman became the Branson postmaster in 1924, then justice of the peace in 1930. This unidentified group was photographed at the stave mill in 1914. (Courtesy of BCM.)

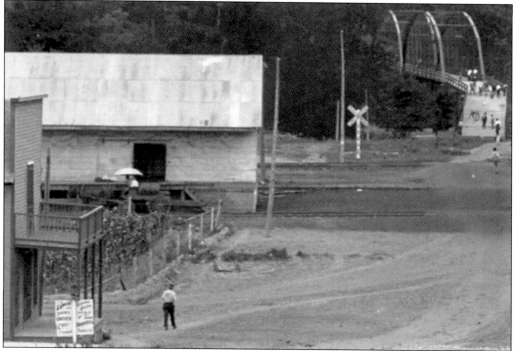

Branson's Main Street wagon bridge across Lake Taneycomo is visible in this 1916 photograph. The sign in front of the restaurant in the first building on the left details the lunch menu. In addition to short-order chili, the dining room offered a full meal with tapioca pudding for dessert. (Courtesy of First Baptist Church of Springfield.)

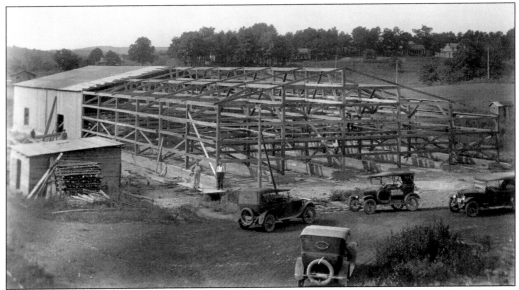

In 1912, tobacco growers in the Branson area formed a company with $15,000 in capital stock. They purchased land, built a warehouse, and laid a spur to the railroad. The White River Valley became the largest tobacco-producing center in the Ozarks, as well as one of two west of the Mississippi River. In 1923, the former Branson Supply Company building, located near the railroad on Main Street, was rented to establish a tobacco factory in Branson. Once fully functional, it employed 30 to 35 men. At 14,560 square feet, the tobacco barn (shown above in 1924) was the largest barn in Taney County. In 1927, unidentified men were photographed during the annual tobacco auction, which featured 500,000 pounds of tobacco up for auction, yielding $2 to $25 per hundred. (Both, courtesy of Springfield Museum on the Square.)

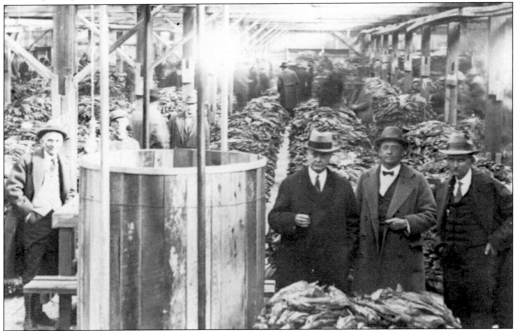

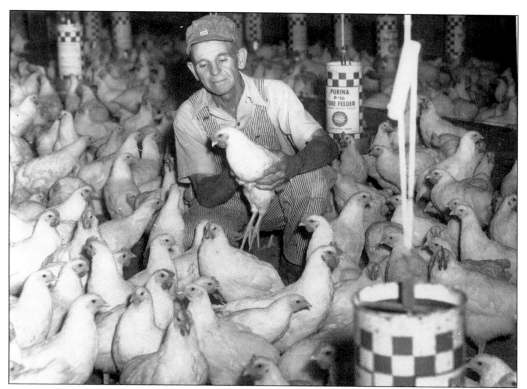

In October 1913, the *Springfield Missouri Republican* reported the opening of an up-to-date experimental poultry-breeding farm just half a mile south of Branson. An educator and publisher of the *Rural Ozarks* and the *White River Leader* newspapers, Eli J. Hoenshel planned to operate the Lakeside Poultry Farm on his Lake Taneycomo farm. Hoenshel partnered with George W. Mairn, an expert poultry breeder and member of the American Association of Poultry Breeders. They began with 1,000 white leghorn laying hens but planned to breed at least five additional full-blooded poultry varieties. In 1920, an unidentified man (above) fed the chickens while unidentified children (below) chased them in the yard. In September 1925, Hoenshel became ill and died of stomach cancer while in a Springfield hospital. (Both, courtesy of WRVHS.)

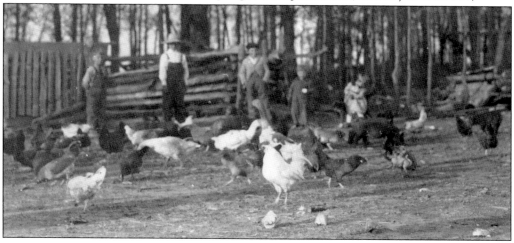

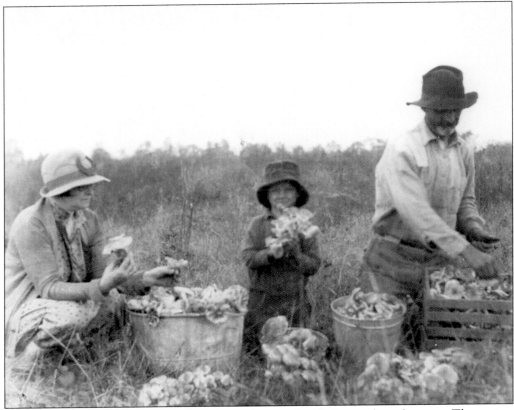

The forested hills of the Branson area were known for their morel mushrooms. The region produced ideal growing conditions, with dead or dying timber falling along the banks of the many streambeds and near running river water. In the early 1900s, Springfield bakery owner and amateur photographer Domino Danzero and his family spent the day picking hundreds of mushrooms. (Courtesy of MSU.)

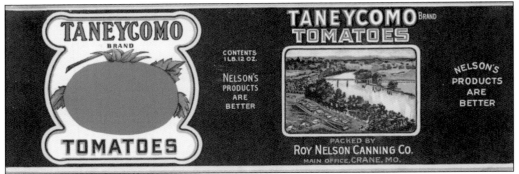

Following the establishment of a new canning factory in 1915, a large peach crop and nearly 400 acres of tomatoes were planted in the Branson vicinity. Stone County canning factory owner Roy Nelson carried Taneycomo Brand Tomatoes. The Branson box factory, another new industry, had many new contracts for peach and tomato crates, while the Branson Fruit Growers Association marketed the produce in Springfield. (Author's collection.)

In 1913, Hobart G. McQuerter began the Sammy Lane Resort campground along Lake Taneycomo, south of the Main Street Bridge. Already the owner of a boatbuilding factory and bulk gasoline supply business, McQuerter expanded into sightseeing tours with his Sammy Lane Boat Line. Posing on the Sammy Lane Boat Line dock in 1946 are, from left to right, Dorothy and Walter Justice, unidentified, and Ray and Grace Gayer. (Courtesy of MSU.)

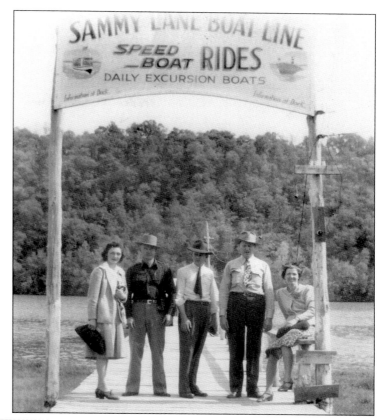

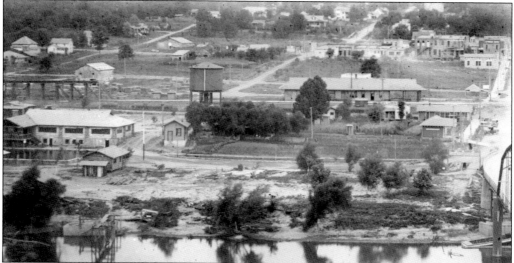

Despite his successes, Hobart G. McQuerter experienced great loss in 1922. Early in the year, both his mother and brother Jim died. Then, in August, his 31-year-old sister, Allie McQuerter, drowned herself by leaping into Roark Creek where it joins the White River at Branson. It is sad that the waters supplying McQuerter's livelihood were used by his only sister to take her life. Shown in 1926 is the Sammy Lane Resort, with Branson and the depot behind it. (Courtesy of MSU.)

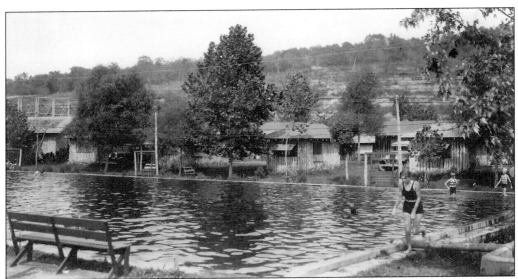

In 1923, Hobart G. McQuerter built a two-story native-rock building for a store and office, with living quarters above. The following year, he built 12 camping shelters, creating the Sammy Lane Tourist Park. In 1925, he added a pool, bathhouse with showers, screened-in kitchen, and pavilion. These unidentified guests were photographed in 1929, swimming in the 60-foot-by-150-foot pool, with a depth of up to 10 feet. (Author's collection.)

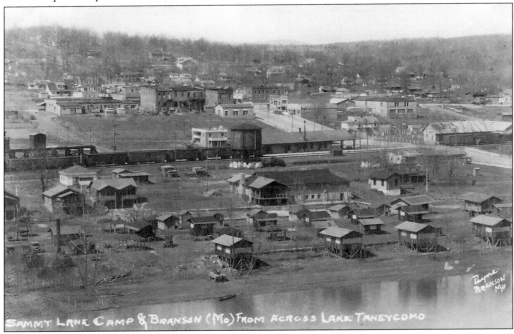

In addition to landscaping the Sammy Lane Tourist Park, Hobart G. McQuerter built 18 additional shelters in 1926 to accommodate the expanding automobile tourism. Eight new cabins were built on stilts along the shoreline and secured by cables in case of flooding. Branson and the Sammy Lane Camp were photographed from across Lake Taneycomo in the winter of 1929. Note that the huge pool has been drained. (Courtesy of BCM.)

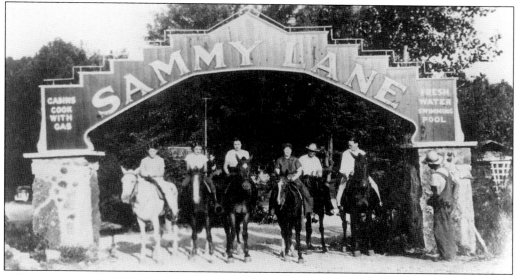

Admission to the Sammy Lane Tourist Park was charged at the gate, but locals could purchase season passes to the pool. In 1929, the *Joplin Globe* described it as "one of the most complete resorts in the Playgrounds area." By the 1940s, there were 50 cottages available, including year-round cabins with fireplaces. The Sammy Lane amenities included tennis, Ping-Pong, badminton, horseshoes, shuffleboard, golf, riding, fishing, boating, dancing, and on-site dining with a café. (Courtesy of BCM.)

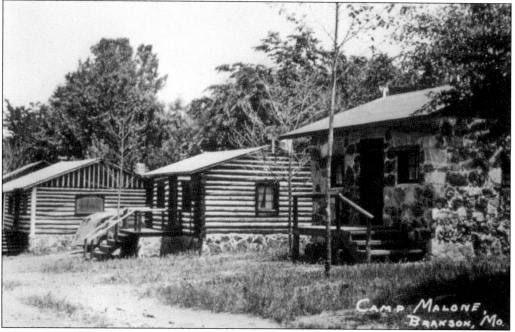

The traditional log and native-stone cabins at Branson's Camp Malone were typical of the resorts developed to accommodate automobile travelers in the late 1920s and throughout the Depression era. Traveling by automobile allowed flexibility in vacation length. Previously, tourists stayed for an entire season after an arduous trip getting there. No longer dependent upon railway schedules, travelers came and went at will. (Courtesy of Springfield Museum on the Square.)

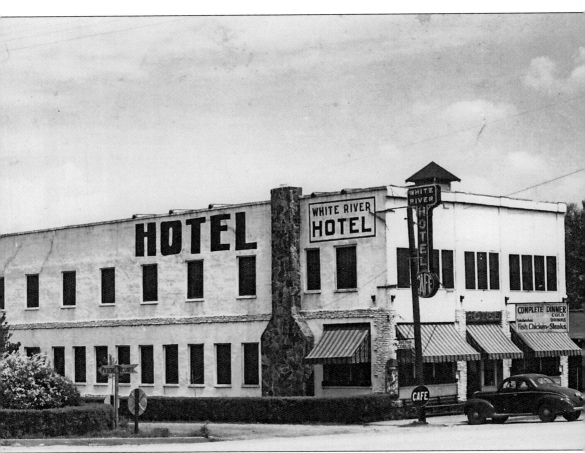

In 1930, the White River Hotel became the outpost for several law enforcement officers and postal inspectors in anticipation of the apprehension of notorious bank robber William Harrison "Jake" Fleagle, who had been living in the area for several months using an alias. Two years earlier, Fleagle, his brother Ralph, Howard Royston, and George Abshier robbed the First National Bank of Lamar, Colorado. They killed A.M. Parrish, the bank president, and his son J.F. Parrish, the bank cashier. Assistant cashier E.A. Cosigner and bank teller B.A. Lounger were taken hostage as the thieves escaped with $219,000. Dr. William W. Wineinger was summoned to Jake Fleagle's horse ranch in Kansas to treat a gunshot wound Royston had received. Fleagle later shot Cosigner and Wineinger to keep them from identifying anyone. Captured in Illinois, Ralph is believed to be the first prisoner transported by airplane. He, Royston, and Abshier were hanged in the Colorado State Penitentiary. Fleagle died on October 15, 1930, from a gunshot wound he received during his apprehension on a train at the Branson depot. (Author's collection.)

A 1939 Ford with suicide doors is parked in front of Lee's Novelty Shop, which sold Como-Craft Pottery. Harold Horine held patents on the manufacturing process of Como-Craft Pottery. He and his wife, Maude M., owned Mount Como Inn and Restaurant at the junction of Highways 65 and 165, which they dubbed the "South Gateway to Table Rock Dam." Maude, a writer, was friends with Rose O'Neill, creator of the Kewpie Doll. (Author's collection.)

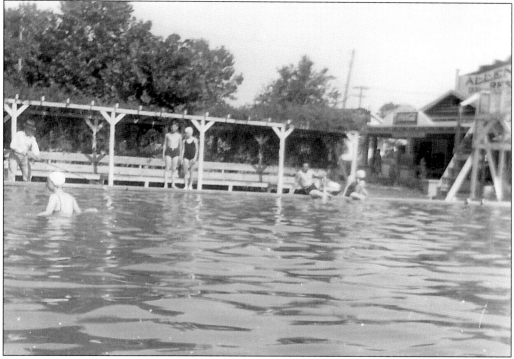

Located on the Roark inlet just one block off Highway 65 at the north end of Branson, the Allendale Resort featured a 250,000-gallon filtered swimming pool, hot-water showers in every cabin, and the clubhouse, which featured a restaurant with a dance floor and orchestra. Other amenities included Ping-Pong, shuffleboard, volleyball, horseshoes, and a playground. Boats and horses were also available. (Courtesy of BCM.)

During the summer of 1936, the Ray John Gayer family of Boone, Greene County, Missouri, vacationed in Branson. They stayed at the Allendale Resort, which was ideally located near golfing, fishing and boating, hiking, and horseback riding. Above, Ray, president of the Springfield Southwest Commission Company Union Stockyards, takes time to relax in a porch rocker at their cabin, Smileawhile. Meanwhile, his wife, Grace Christine, and his children, Harold Ray, 11, and Regena, 10, enjoyed swimming in the huge pool. At left, Harold and Regena pose near the Wernevrin cabin on the way to the pool. During the 1940s, Ed Aehle operated the resort, and then Larry and Adeline Gill took over as managers sometime before 1950. (Both, courtesy of BCM.)

Sharp's Log Cabin Resort offered furnished lakeside cabins with running water and gas cooking. Rented by the day or by the week, rates began at $24 weekly for two people, while a family of six enjoyed a week's stay for only $54. Amenities included a crystal-clear pool, croquet, shuffleboard, and a playground. Branson's new bowling alley was located just three blocks away, and boats or horses could be rented as well. (Courtesy of BCM.)

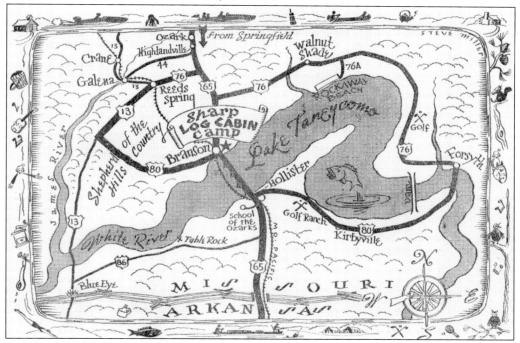

In 1930, Claude Sharp, owner of Sharp's Log Cabin Camp, purchased a new 10-passenger boat for his patrons' use on Lake Taneycomo, providing boat rentals for reasonable rates. By the 1940s, H. Kendall Mulcahy and his wife, Lilliemae, managed the resort. This early 1940s map of the Lake Taneycomo region was used in Sharp's brochure, advertising rustic log cabins with modern amenities, such as running water and gas stoves. (Author's collection.)

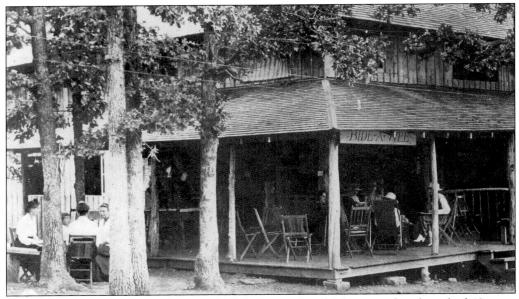

In 1912, guests trudged up Presbyterian Hill, luggage in hand. They stayed in the stilted 40-room Bide-A-Wee Inn, covered with board-and-batten cedar. A modern $40,000 hotel replaced it in time for the 13th-annual Presbyterian Young People's Conference in 1922. Designed as a local retreat, the Women's Christian Temperance Union, Chautauqua Association, and Freemasons all used the site year-round by the 1920s. (Courtesy of Lucile Morris Upton.)

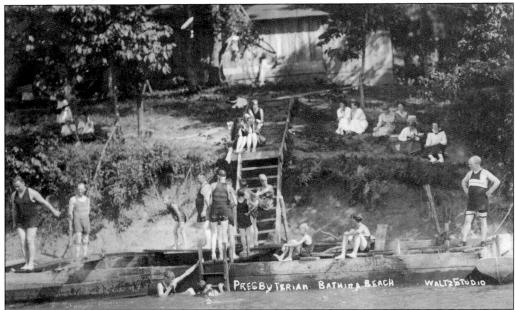

The Presbyterian Hill bathing beach was a sandbar island opposite the mouth of Coon Creek, about 200 feet from the shore beneath Presbyterian Hill. During the 1920s, bathers enjoyed a day at the lake, unaware that a tragedy had taken place there just a few years before: in July 1916, Henry J. Shores, a 23-year-old from Springfield, suffered a heart attack and drowned while crossing from the sandbar to the shore. (Courtesy of Lucile Morris Upton.)

As newlyweds, banker Buford G. Madry and his wife, Josephine Voelpel Madry, relocated from Aurora, Missouri, to Branson in May 1924. Within a few years, Josephine Madry and Eula Whelchel Thornhill, together, owned and managed the Anchor Travel Village above. Open year-round, the Anchor Travel Village was conveniently located on Highway 65, overlooking Lake Taneycomo and the swimming beach. Photographed below under the Anchor Travel Village sign in the 1930s are, from left to right, an unidentified boy, Eula Thornhill, Josephine Madry, and Johnnie N. Randolph. A Branson resident, Randolph served during World War I. By the 1950s, their Anchor Travel Village advertised air-conditioned or air-cooled cottages and a coffee shop. (Both, courtesy of BCM.)

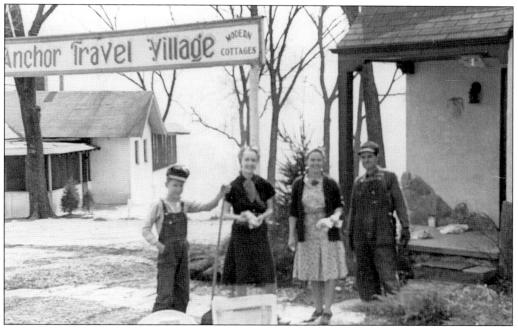

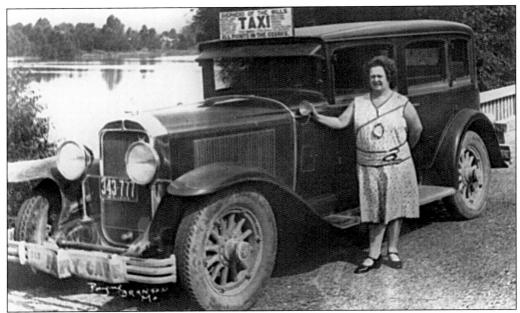

For more than 30 years, Pearl "Sparky" Spurlock made a lucrative career conducting guided tours in her "Shepherd of the Hills" taxi. She traversed rugged, brutal terrain across Dewey Bald to the former homestead of John and Anna Ross, near Mutton Hollow. The Rosses gained notoriety following the 1907 release of Harold Bell Wright's *The Shepherd of the Hills*. Spurlock shared her love for the beauty and romance of the region through her stories to tourists. She corresponded extensively with Wright to establish how characters from his book were shaped by their local prototypes and how its setting related to local spots, which became landmarks. Spurlock's book of her Ozarks stories was published in 1936. She is shown beside her taxi in the 1930s (above) and inside it during the 1940s (below). (Both, courtesy of BCM.)

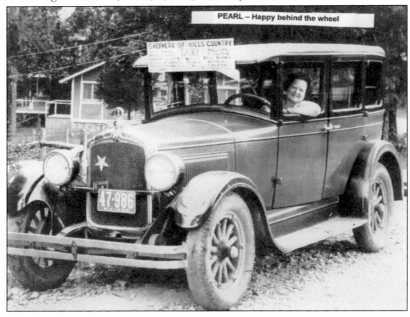

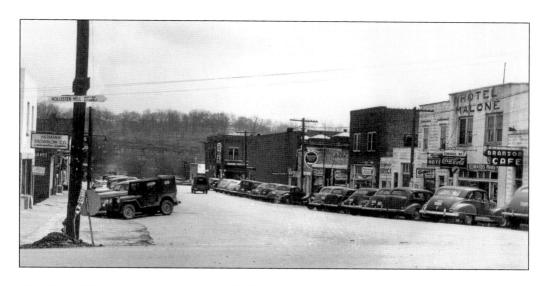

After World War II, two surplus Army Willys Jeeps were photographed above on Main Street. J.W. Brownlow was the general manager of the Hermann-Brownlow Automotive Company, seen on the north side of Main Street. On the south side of the street are, from left to right, Tom Epps Western Auto Associate Store, Hazel's Beauty Shoppe, the Goofy Souvenir Shop, the Hotel Malone, Edwards' Market, and the Branson Café. During the flooding of Branson and Hollister in 1927, the Hotel Malone had 4.5 feet of water in its office and dining room. The owners redecorated and installed the electric "Hotel" sign two years later. The Branson Café opened on Main Street in 1910 and is the oldest restaurant in Branson. The 1952 photograph below shows a bustling Commercial Street, looking north from College Street. (Above, author's collection; below, courtesy of BCM.)

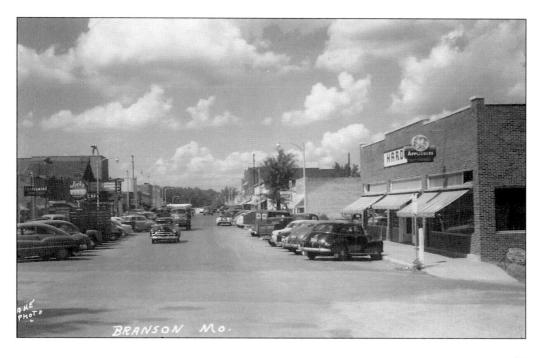

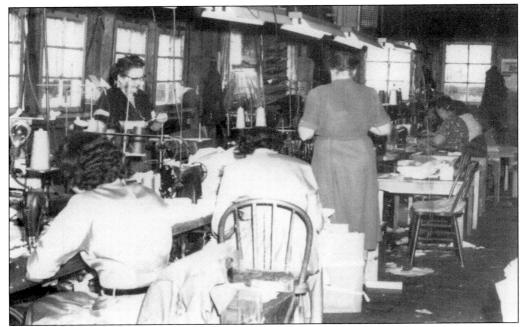

In this 1940s photograph, unidentified women are shown hard at work in a Branson garment factory. Charley Fain, Branson Chamber of Commerce president in 1959, reported that the Branson-Hollister Industrial Development Corporation had received a $95,000 loan (nearly $755,000 today) from the Small Business Administration for an addition to the Branson Manufacturing Company's garment factory. Hagle's garment factory was located at the current site of the Branson Landing. (Courtesy of WRVHS.)

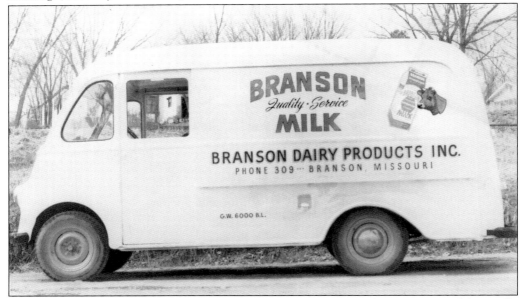

Begun in 1958 in Branson, Missouri, Branson Dairy Products, Inc., used this 1950s van to deliver milk, cream, butter, and other dairy products to Branson and Hollister area businesses. The original owner was listed as Derald Elwood Watts of Branson, who passed away in 1992. (Courtesy of WRVHS.)

An unidentified man poses with his homemade "rat rod" in the early 1950s. Behind him is the Jim M. Owen Everything for the Sportsman shop, with a Woodless Willys station wagon out front. These Willyses were designed in 1946 with an all-steel body, which was safer and easier to mass-produce and maintain. Plus, they resembled the real woodies. The shop belonged to Jim Owen, famous for his float trips. (Courtesy of WRVHS.)

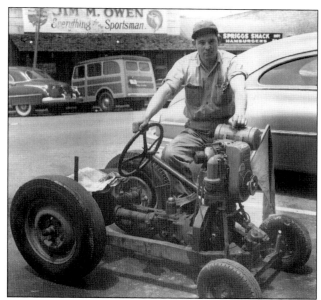

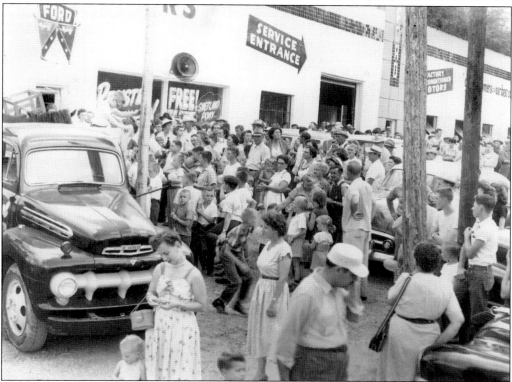

H. Harrison purchased the land on which this Ford Motor Company dealership stands for $300 from the Branson Town Company in 1906. Over the years, the site had multiple owners: the Bank of Branson, J.G. Burger, Lorene Merrick, A. Fields, and Edith and W.O. Duston, who opened the dealership in the early 1940s. In 1948, the Dustons expanded for more showroom space, and during the grand reopening celebration, a Shetland pony was given away. (Courtesy of WRVHS.)

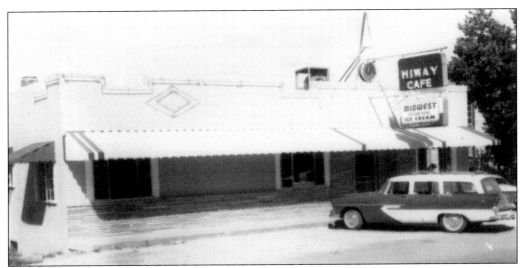

Howard and Evelyn Holmes owned the Hiway Café, located on Highway 65. The establishment boasted air-conditioning for the comfort of its patrons while enjoying the famous catfish dinners, Southern fried chicken, or choice steaks. Meals included hot rolls or corn bread, complete with a slice of homemade pie. Plate lunches with sandwiches were also available. (Courtesy of WRVHS.)

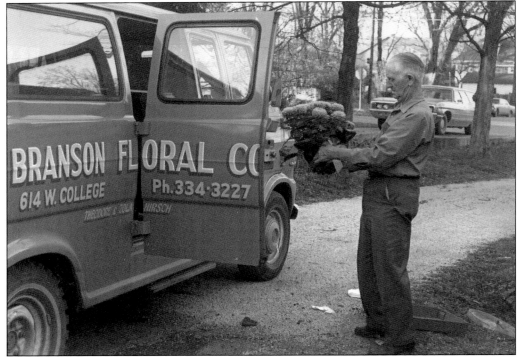

Theodore "Theo" Hirsch and his wife, Zola, ran the Branson Floral Company for several years. In the *Taney County Republican*, they advertised, "Flowers for all Occasions: Potted Plants, Corsages, and Sprays." They could be reached at Phone 27 in the 1940s. In the 1950s, they began sending flowers nationwide through FTD. Theo is pictured here on a delivery run in the early 1970s. (Courtesy of WRVHS.)

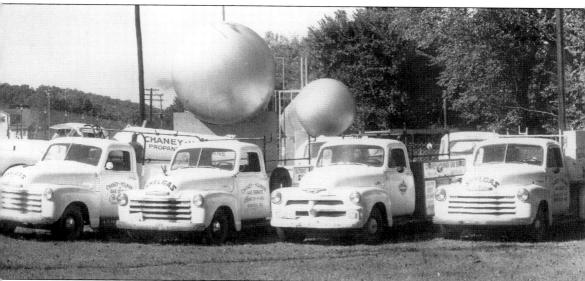

After World War II, Finis Chaney returned to Branson, where he opened the Chaney-Holman LP Gas Company with Minard C. Holman, son of Charles Holman, a civil engineer who came to Branson in 1911 to work on the Powersite Dam. They sold butane to remote areas, which had to be buried underground to keep it warm. In the 1950s, propane replaced butane in rural areas. Chaney-Holman provided propane tanks, stoves, refrigerators, and air-conditioning systems. They even installed a propane air-conditioning system in Marble Cave. Finis's brother Homer worked with him for a couple of years before becoming the Branson postmaster. His other brother Ward worked with him for over 25 years. Their bulk propane plant was located near Mang Field, which contained a baseball diamond and swimming pool. Their office was located near the end of Main Street, where the Branson Landing is today. Finis's son Jerry would become a one-third partner, later selling the business in 1982. Jerry Chaney reported that his grandfather George Albright moved to Branson in 1912 and also worked on the Powersite Dam. (Courtesy of WRVHS.)

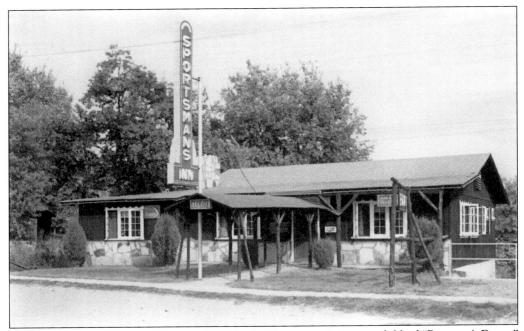

Recommended by Duncan Hines and AAA, the Sportsman's Inn was dubbed "Branson's Finest" in 1953. Located just three blocks south of the blinking light on Highway 65 in Branson, the establishment was famous for its rainbow trout, catfish, fried chicken, barbeque ribs, and fried chicken steaks. The Sportsman's Inn advertised cooking in an all-electric, all-white kitchen with breakfast served 8 to 11 a.m. featuring Ozark country cured ham. (Author's collection.)

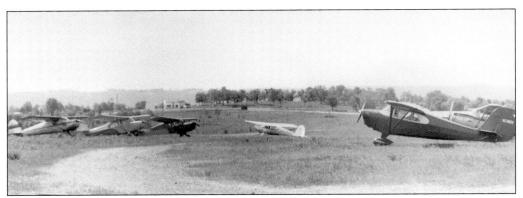

Originally, the Branson Airport was located on Highway 76 west, now the site of the White Water Theme Park. Although the airport was just a dirt landing strip, voters repeatedly turned down a bond issue to improve the airport during the 1960s. After the School of the Ozarks airstrip opened in 1970, the Branson airport closed. In 2009, the new Branson Airport opened 10 miles south of the Branson strip. (Courtesy of WRVHS.)

Six

CLUBS AND
ORGANIZATIONS

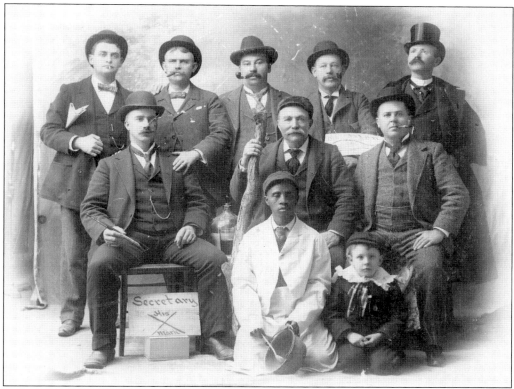

In the 1890s, Springfield Frisco Railroad men formed the Mollyjoggers Fishing and Hunting Club on the James River, north of Branson. Much like the legendary Jim Owen and his White River float trips during the 1930s, the Mollyjoggers provided locals and tourists the opportunity to camp, fish, float, and hunt. Jokingly named the "Mollyjoggers" after a small, spotted, and worthless minnow, they constantly tried to outdo each other, playing jokes and telling tales. Every member was given a camp nickname and position. Membership included, from left to right, (first row) two unidentified (known as "Shorty," the cook, and "Little Eddy," the mascot); (second row) Wilbert S. Headley ("Eel," the secretary), Cyrus H. Patterson ("Old Phoebe," the president), and John C. Crenshaw ("Little Hawkins," the vice president); (third row) John F. Dunckel ("Muldoon," the editor), John R. White ("Jutta," the chemist), Benjamin L. Routt ("Postal," the commissary), William D. Massey ("Pa," the fish commissioner), and Edward F. Burke ("Baldy," the master of the hounds). Dunckel's book *The Mollyjoggers: Tales of the Camp-Fire* was published in 1906. (Courtesy of SGCLD.)

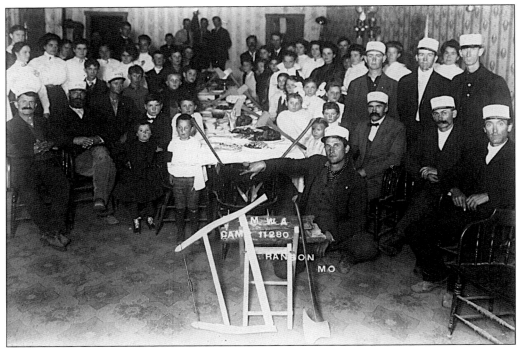

In 1907, members and families of the Modern Woodmen of America (MWA) Camp 11280 were photographed in Branson. MWA, the third-largest fraternal benefits society, began in 1883 to protect families following the breadwinner's death. Members were not restricted by race or religious affiliation, but certain professions, such as bartenders, baseball players, and railway men, were excluded. Another requirement involved living in one of 12 "healthy" states, which included Missouri. (Courtesy of BCM.)

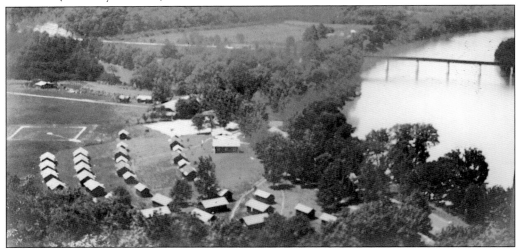

The Hollister Young Men's Christian Association (YMCA) Interstate Recreation Camp and Summer School, known as "Camp Ozark," began when 40 YMCA members of St. Louis came to the area in 1908. The following year, Hollister developer W.H. Johnson donated 60 acres below the bluff of Presbyterian Hill. Intended as a family retreat, Camp Ozark aided in the development of tourism in the region. (Courtesy of WRVHS.)

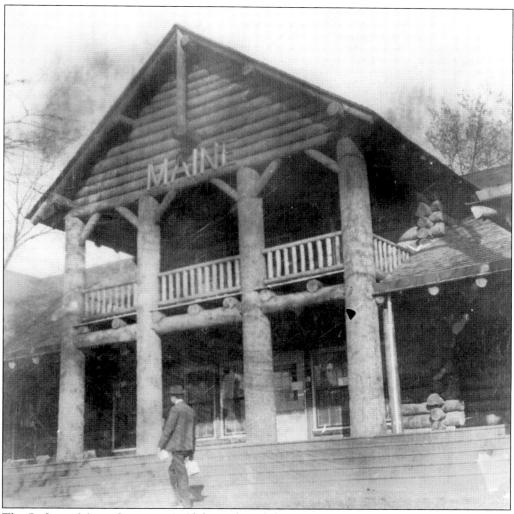

The St. Louis Maine Sportsmen's Club purchased the State of Maine's exhibition building from the 1904 Louisiana Purchase Centennial Exposition World's Fair in St. Louis. It acquired 207 acres overlooking the White River near Hollister in Taney County. In 1905, the Maine exhibition building was dismantled, shipped to Branson, and then hauled across the river and reassembled on the Maine Club property. The next year, the Maine Club opened as a lodge for its St. Louis members who came there to hunt and fish. The new White River Railroad into Hollister could bring in 50 members at a time. By the mid-1910s, the members had lost interest and sold the lodge to Louis Siebert, who ran it as a hotel for two years. In 1915, the School of the Ozarks purchased it for $15,000. It became known as Dobyns Hall but was destroyed in a fire on February 1, 1930. (Courtesy of WRVHS.)

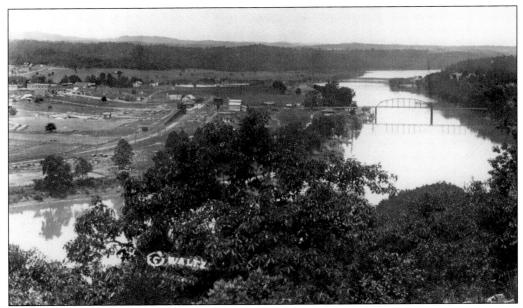

In 1908, a group of 80 Presbyterian elders determined a site was needed for conferences, conventions, and group meetings. The next year, the Southwest Presbyterian Assembly purchased 160 acres on the bluff overlooking Branson. In 1919, Lucile Morris Upton photographed Branson (above) while staying at her Presbyterian Hill cabin. Professionally landscaped to preserve its rustic beauty, Presbyterian Hill included an assembly hall, dining pavilion, dormitories, rustic bungalows, and tents, which were photographed below in 1923. (Above, courtesy of Lucile Morris Upton; below, courtesy of Gerry Chudleigh.)

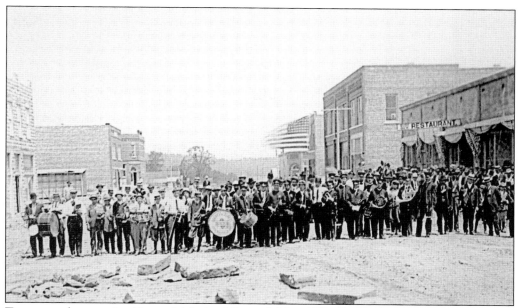

Two years after opening Hoover's Music of Springfield in 1912, Herbert Lee Hoover and his Little Hoover's Big Band performed on Commercial Street in Branson, with a 48-star US flag waving behind the musicians. Two stars representing the states of Arizona and New Mexico had been added in 1912 for a total of 48 stars, which were arranged in six rows of eight, along with 13 stripes representing the original 13 colonies. (Courtesy of BCM.)

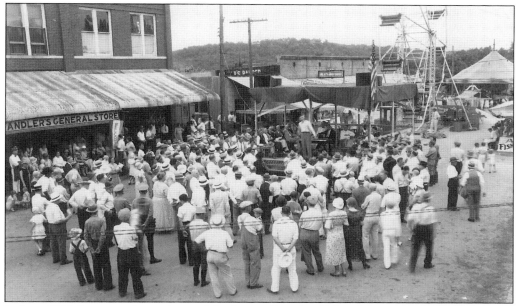

In June 1926, Branson planned one of the largest Fourth of July celebrations ever held in Taney County, Missouri, under the auspices of the Branson Ball Club. The Missouri Pacific Railroad and the Missouri Farmers Association (MFA) Club held a big thoroughbred Jersey show and sale. They also demonstrated food products, packing, and grading. The World Mimic Shows entertained the citizens with their rides and attractions. (Courtesy of BCM.)

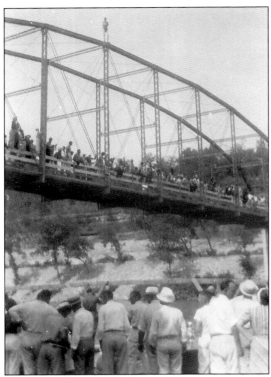

In 1930, Branson businessmen sponsored a Water Carnival on Saturday, August 9. The aquatic events included boating and swimming races, diving contests, and a canoe regatta, as well as freak stunts. Winners of the swimming races received prizes in gold, including the winner of the three-mile freestyle who was awarded $25 in gold! Here, a young man is perched atop the Branson Bridge, ready to dive into Lake Taneycomo. (Courtesy of WRVHS.)

In 1936, the Home Demonstration Club was photographed beside a 1928 Chevrolet, which was originally a Branson school bus driven by Clem Whorton. Home Demonstration Clubs began as early as 1910 and continued through World War II. From left to right are (first row) Helen Fletcher, Roxie Fletcher, and Jerry Chastain; (second row) Leona Lewallen, Nora M. Nevins, Kathryn Mae Chastain, Audrey Sare, unidentified, and Margaret Hull; (on the bus) unidentified, Bell Hembree, and Celia M. Farrar. (Courtesy of BCM.)

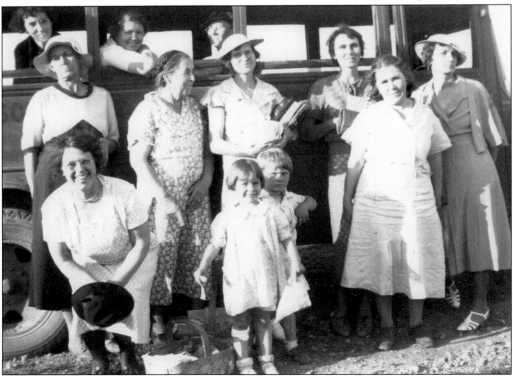

On May 28, 1939, Charles L. Grimm (right), commander of the Holcomb-Fream Post 1443 Veterans of Foreign Wars (VFW), erected a new "Welcome" sign for the city of Branson near the entrance to the Sammy Lane Resort. Photographed with Grimm are George L. Albright (left), the grandfather of Jerry Chaney of the Chaney-Holman LP Gas Company of Branson, and an unidentified man. (Courtesy of BCM.)

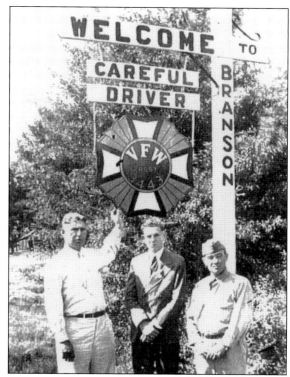

In 1939, the Branson-Hollister Rotary International Club put on a Rotary Show. Like many of the service club shows of that era, it included a takeoff on the popular vaudeville minstrel shows, which were performed in blackface. The band members in the front row are, from left to right, William Fanning, Harold Meadows, David Shanahan, Kenneth Jergenson, John Cook, and Jim Edwards. The other men are unidentified. (Courtesy of BCM.)

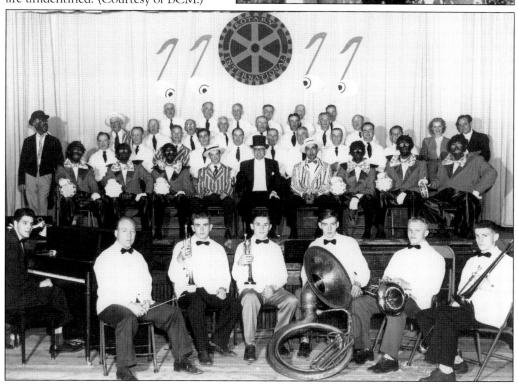

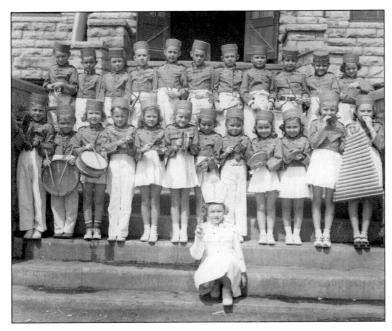

On June 25, 1939, the VFW sponsored a picnic in the Branson City Park. Events included boat races on Lake Taneycomo sponsored by the Springfield Yacht Club and a parade down South Commercial Street. Breb Walker directed the Community Band and presented his 30-piece Juvenile Band. In uniform and sporting instruments, the children in the band posed for a photograph prior to their performance. (Courtesy of BCM.)

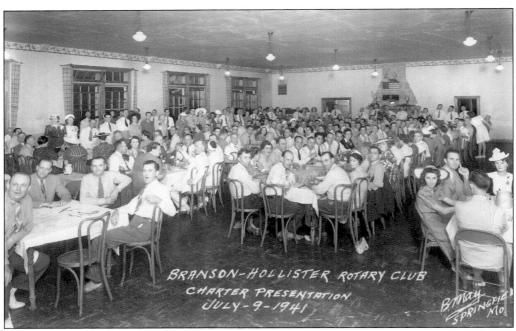

In July 1941, the Branson-Hollister Rotary Club members were photographed during their charter presentation. Charter members included Joe Alexander, Fred Baker, Harry Evans, Vernon Jones, Bill Jones, Jack Jones, Buford Madry, Isaac Thompson, R. Oscar Whelchel, Jack Allen, and Bob Good. In 1921, Bob Good became president of the School of the Ozarks. Another School of the Ozarks president, Dr. M. Graham Clark, became Rotary Club president for the 1960–1961 term. (Courtesy of BCM.)

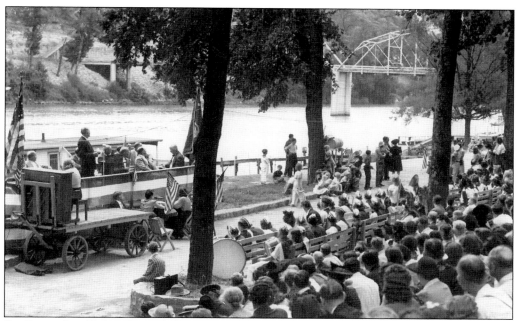

On September 13–14, 1941, a dedication ceremony, complete with band concerts and picnics, was held for the Works Progress Administration (WPA) waterfront recreation project. The Branson Junior Chamber of Commerce sponsored motorboat races under the direction of the Springfield Yacht Club. The yearlong construction project consisted of a flagstone walkway (700 feet long by 21 feet wide), stone bleachers (accommodating 1,250 people), outdoor fireplaces, concrete tables and benches, and a municipal dock. The above photograph of the new waterfront was taken during the ceremony. Note the upright piano on the dray on the walkway. Saturday, September 13, was designated as Hillbilly Day, and Arch Mayden was photographed below leading Ann Goforth on horseback during the Hillbilly Day Parade. (Both, courtesy of BCM.)

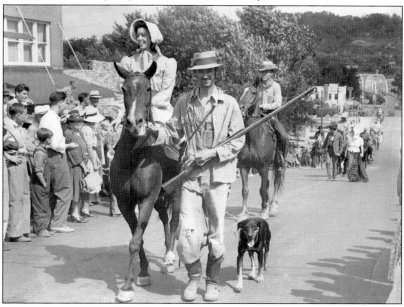

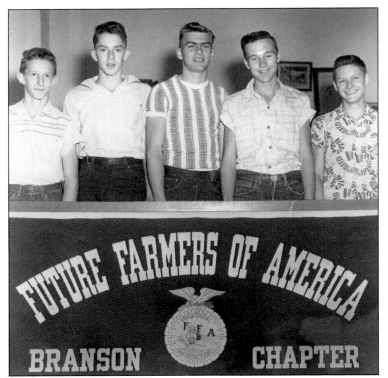

The Future Farmers of America (FFA) was an agriculture education advocacy group founded in Kansas City, Missouri, in 1928. Granted a federal charter in 1950, it began admitting girls in 1969. It was later renamed the National FFA Organization to remove itself from the stigma of farming. Photographed during the 1950s, the Branson FFA members are, from left to right, Marvin Fausett, Larry Doubt, Chuck Large, Adrian Brown, and Dean Wallace. (Courtesy of WRVHS.)

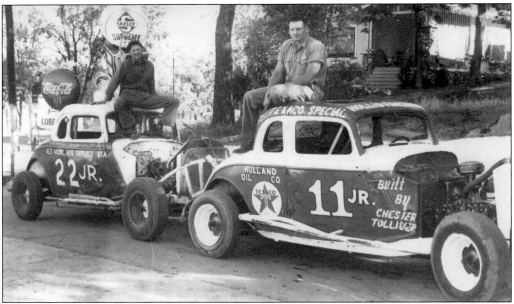

Stock car racing is a form of auto racing most popular in the United States. An unidentified man sits on top of Al's Mobilgas Service Station No. 22 Jr. Bob Holland (right) was photographed sitting on top of the Texaco Special No. 11 Jr. of the Holland Oil Company Texaco Station. Chester Tolliver of Hollister, Missouri, had built the Texaco Special during the 1950s. (Courtesy of WRVHS.)

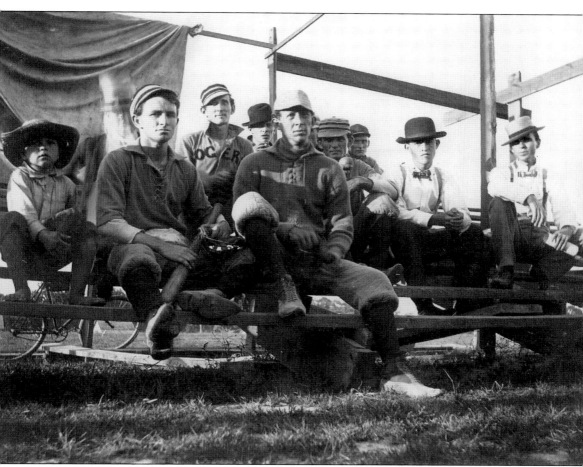

In 1922, the Branson Sluggers received new uniforms, which were purchased with money raised by subscriptions from Branson businessmen. The team went on to end its most successful season, winning 21 out of 23 games played. It even beat the Springfield Friscoes that year, earning the Championship of the Southwest title. In spite of a huge storm blowing over the Branson baseball grandstand, the Sluggers won 25 out of 30 games played in 1923. The team's continued success drew larger crowds to the games each year. By 1925, extensive improvements to the Branson ballpark grandstand had become necessary. The grandstand was enlarged, with official seats built, and the parking area for automobiles was expanded as well. In May 1925, the Sluggers played the Galloway Outlaws. It was the second game pitched for the Sluggers by former Springfield Midgets hurler Carl Shelby. The largest crowd of the season came out to watch Shelby use his famous knuckleball against the Outlaws. (Courtesy of MSU.)

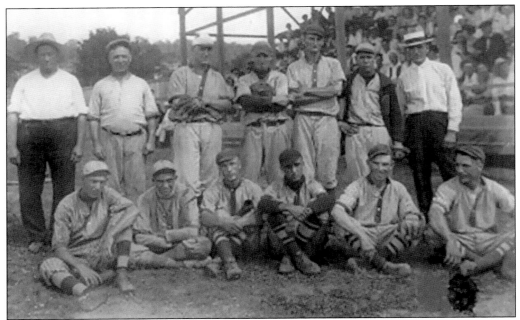

The 1921 Missouri semipro champion Branson Sluggers are, from left to right, (first row) Ray Justus, Silas Bennett, Joe Alexander, Cyrus Bennett, Bethel Eiserman (who later became a Slugger manager), and Pete Alexander; (second row) C.H. Nichols (umpire), Ken Kenton (manager), Edgar Spence, Homer Keeton, Ike Thompson (pitcher), ? McCrellis, and Ern Duvall (business manager). (Courtesy of BCM.)

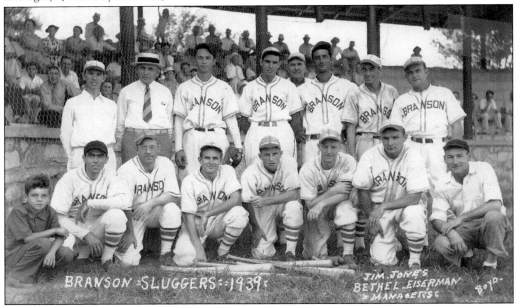

The 1939 state champion Branson Sluggers are, from left to right, (first row) an unidentified bat boy, ? Rogers, Bob Groth, Ray Russell, Bob Grider, John Flumerfelt, ? Miller, and Jim Jones; (second row) Bethel Eiserman and Vernon Hames (managers), Jim Davis, Craton Noel, Mel Jackson, Clarence Evans, George McDaniel, and Tom Keeler (umpire). (Courtesy of BCM.)

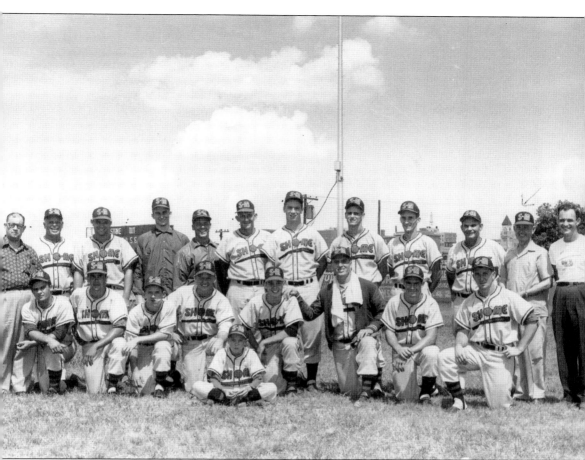

Founded in 1958, the Sho-Me Youth Baseball Summer Camp and Baseball School is one of the oldest established baseball schools in the country. Sho-Me specializes in the teaching of proper baseball fundamentals, with a coaching staff consisting of college coaches, former major-league players, and even hall-of-famers. It is the camp's goal to prepare each player for the next level. Sho-Me is the premier choice among youth sports camps for baseball instruction. From hitting to pitching, Sho-Me provides the ultimate youth baseball training experience for players from ages 8 to 18. Many former graduates have gone on to play baseball at the high school, college, professional, and major-league levels. (Courtesy of BCM.)

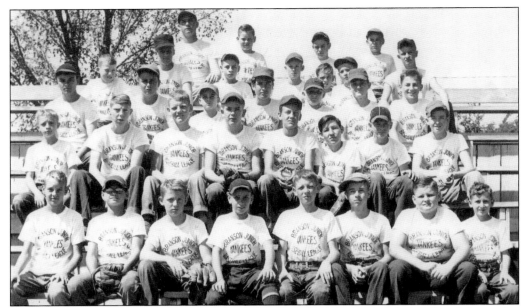

On August 26, 1949, the Branson Junior Baseball League Yankees team included, from left to right, (first row) Jones, Laing, Bearden, Lewallyn, Clines, Michel, Chism, and Gooch; (second row) Cline, Jackson, Meadows, Noel, Jerry, Barnes, Jackson, and Coleman; (third row) Barry, Curbon, Fields, Collins, Akers, Akers, and Shanahan; (fourth row) Shanahan, Dewey, Roland, Crosby, Roberson, Rickman, and Barnes; (fifth row) Wensey, Chism, Gibson, and Davis. (Courtesy of BCM.)

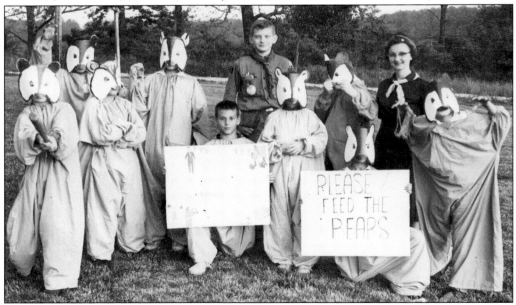

Carmen Eiserman Plummer, den mother of the Branson Cub Scout Den I Pack 93, poses with the troop, wearing their outfits for a program. The boy without a mask holding the sign is Tom Davidson. The boy without a costume is Sammy Waltz, the den master's helper. Also among those in the photograph are Charles "David" Plummer, Mike Gooch, Randy Casey, Joe Hicks, Steve Hensley, Tom Dodds, and Clarence Dunn. (Courtesy of BCM.)

Seven

NATURAL AND MAN-MADE DISASTERS

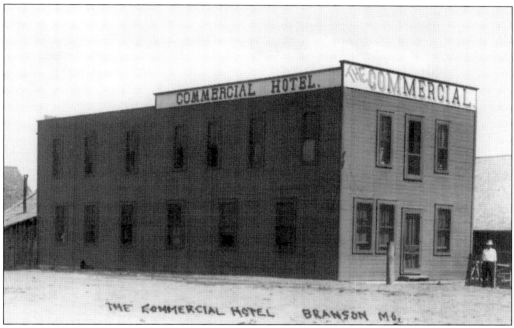

THE COMMERCIAL HOTEL BRANSON MO.

In 1906, Frances "Fannie" Virginia Randall moved to Branson, where she met her fifth husband, Sherman Porter Winch. They married on May 10, 1910. Sherman became the Branson postmaster in 1924 and the justice of the peace in 1930. Fannie was the proprietor of the original two-story Commercial Hotel, located on the southeast corner of Commercial and Pacific Streets. It was notorious as the starting point of the fire on August 1912, which destroyed most of the Branson business district. Sparks from a wood stove ignited linens and furniture in the laundry shed behind the hotel. A hot summer breeze quickly spread the flames to the hotel and neighboring buildings. Branson had no fire department or apparatus, so shopkeepers and citizens hauled water up from the White River. But it could not be carried fast enough. Fannie rushed guests from the hotel and attempted to save her belongings, as did her fellow shop owners. (Courtesy of WRVHS.)

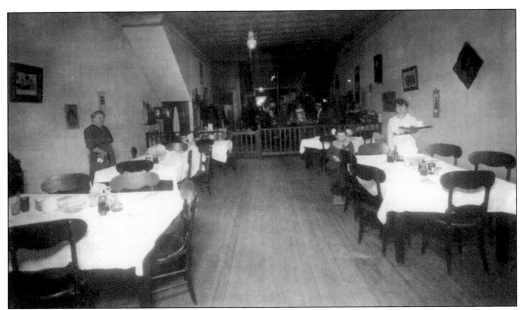

Fannie Winch wrote to her son Ira Henderson on August 30, 1912, describing the situation. She managed to save her piano, four dressers, two davenports, a refrigerator and range, a sideboard, some glassware, her mother's things, and some bedding. An unknown woman (left), Fannie, and her seven-year-old son Raymond Winch were photographed in the Commercial Hotel dining room in 1916. The Winches rebuilt the Commercial Hotel, then sold it in 1919. (Courtesy of WRVHS.)

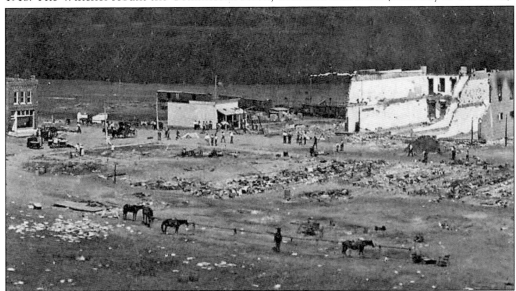

Gone were 21 businesses, including the post office, Jo VanZant's residence in the rear of the livery stable, Whelchel Hardware and Furniture Store, Whelchel-Bennett Millenary Store, a short-order restaurant, Parnell Brothers Mercantile, Troutman Brothers Grocery, Thompson's Store, Patterson Brothers Mercantile, Nichols Shoe Shop, Fritz Schmidt Shoe Shop, a butcher shop, a harness shop, a secondhand store, Boswell's Grocery Store, Aikins Supply Company, and Dr. Mitchel's Drug Store. (Courtesy of WRVHS.)

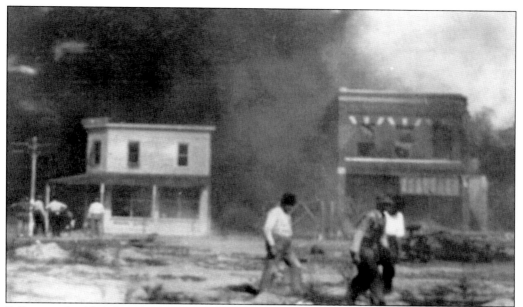

Following the 1912 fire, the only remaining businesses were the telephone building, Sullenger's Saloon and pool hall, the Branson depot, the livery and feed stable, the Branson Hotel, a tin shop, a lumberyard, a grocery, a restaurant, and a barbershop. The awning and plate glass on the Bank of Branson were damaged, but the building was saved. Most of these buildings were isolated from the business district. (Courtesy of BCM.)

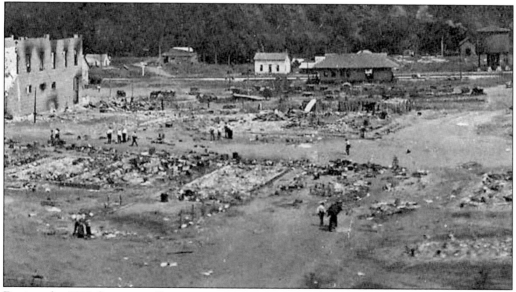

During the 1912 fire, many Branson citizens were in Ozark, attending the Miles murder trial. James Miles pleaded self-defense in the shooting death of Enos S. Rush, struck from across the counter of the Heflin Meat Market in Branson. Twenty-five years earlier, his brother Billy Miles shot and killed "Captain" Nathaniel Kinney, chief of the infamous Bald Knobbers gang. Billy Miles was acquitted of the 1887 shooting, but James served four years in the state penitentiary. (Courtesy of BCM.)

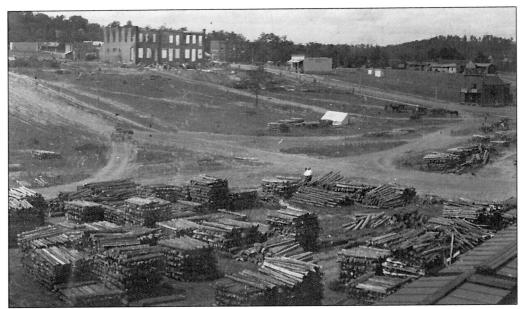

Following the 1912 fire, new buildings were constructed of fireproof material. In October 1913, however, a second devastating fire occurred at the same site. The fire broke out in the St. Clair Grocery & Dry Goods in the Whelchel block, also destroying the contents of the Busy Bee Restaurant and the Brainard Barber Shop. The new concrete structure was damaged by the heat of the blaze but not destroyed. (Courtesy of BCM.)

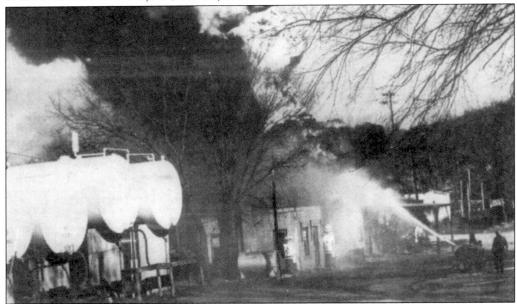

On Friday, November 13, 1964, the Standard Oil Company pump house caught fire while a tank truck was unloading. Ward Chaney and Don Brown disconnected the truck and drove it to safety as the fire alarm sounded. The Branson Fire Department, along with the Hollister, School of the Ozarks, Forsyth, and Rockaway Beach Fire Departments, battled the blaze. Three explosions injured both firefighters and bystanders, creating a mushroom of flaming gasoline. (Courtesy of BCM.)

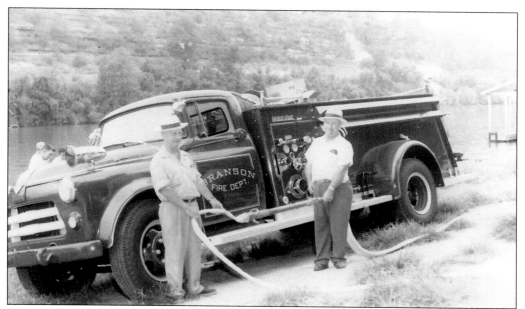

Organized in the late teens, the Branson Fire Department received its first Ford Model T fire truck in 1927. In 1929, the Branson City Council took steps to build a fire station and enlisted volunteer firefighters. During the 1950s, rural fire service began as the Branson-Rockaway Fire Protection District. In 1965, Joe C. Alexander (left) and former Branson mayor Tom A. Epps presented a new fire truck. (Courtesy of BCM.)

In June 1957, a nine-year-old boy got lost while on a squirrel-hunting trip. Jimmy Day had gone hunting with his younger brother, Jerry; his cousin, Kenny Honeycutt; and his dog, Speck. Jimmy spent the night curled up with Speck in the rainy, chilly weather. Taney County sheriff Theron Gideon led the search through the night. Jimmy was found in the morning, hungry but unharmed. (Courtesy of Betty Jane Turner.)

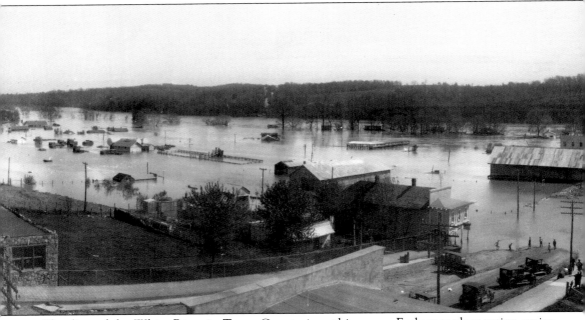

Flooding of the White River in Taney County is nothing new. Early records mention major floods in 1824, 1844, 1884, and 1900. Devastating floods in 1927, 1935, 1938, 1943, 1945, and 1946 increased the public demand for flood control. In April 1927, the White River rose nearly 50 feet, cresting at 28 feet above flood stage in Branson. Five days of continuous rain destroyed local crops while flooding Branson's riverfront and downtown Hollister. It became the worst flood

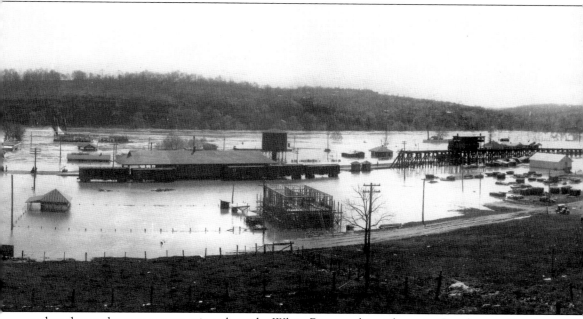

to date due to the new construction along the White River and its tributaries. Residents suffered additional hardships as water and light systems failed when water covered the Powersite Dam. Those residents with stone houses fared better than their neighbors in wood structures, as many of the lighter buildings were swept away by the raging current. (Courtesy of MSU.)

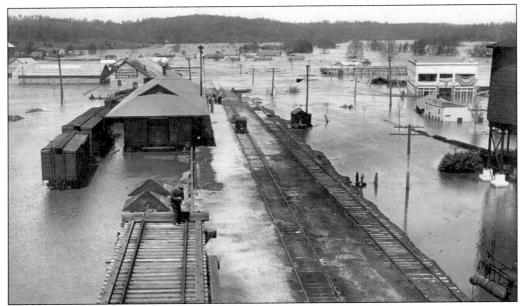

The flooding in 1927 extended the entire length of the White River, all the way to the Mississippi River. Nearly one million people were displaced from their homes at a time when public assistance was not yet available. Despite its raised structure, the Branson depot floor was still covered with two feet of water. The Branson depot and railroad tracks are shown partially submerged. (Courtesy of MSU.)

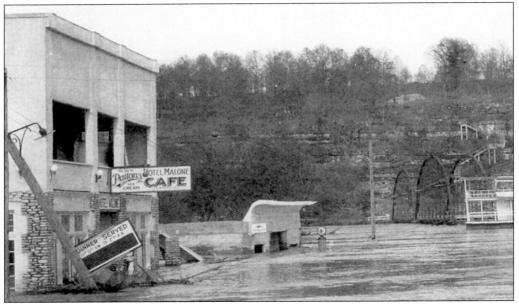

The State Highway Department went to work as the water receded following the devastating 1927 flood. The 300-foot-long west approach to the Branson Main Street Bridge was damaged when the Branson Ice Plant warehouse lodged against it. Lumnite concrete, which sets in 24 hours, was laid for the approach's flooring. Branson became unreachable from the north when the floor of the Roark Creek Bridge washed away. (Courtesy of MSU.)

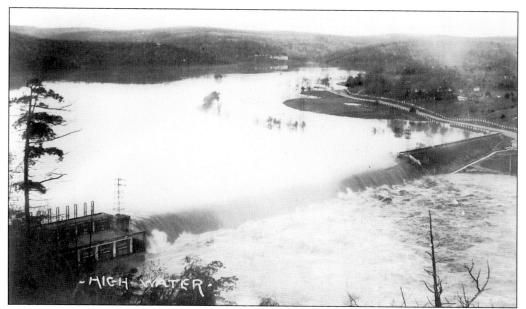

The Sammy Lane Boat Company suffered the largest individual loss when its prized boat, the *Shepherd of the Hill*, broke loose from its mooring during the height of the 1927 flood. It was swept madly down the lake and over the Powersite Dam, where it was smashed into kindling. Just north of the bridge, the Sammy Lane Boat Line buildings and offices were completely wiped out. (Courtesy of MSU.)

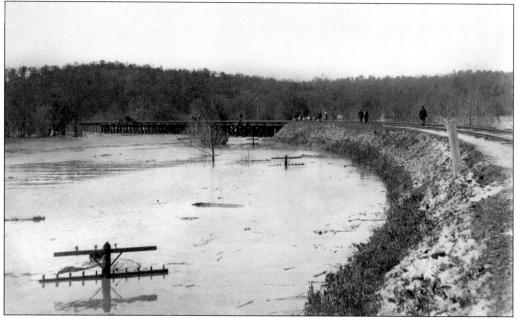

In 1927, floodwaters rose to the bottom of the Missouri Pacific Railroad Bridge. A section of the bridge was washed out by the bombardment of debris forced upstream during the storm. Note the nearly submerged utility poles. Throughout the valley, nearly all of the old water-powered gristmills were destroyed that spring. (Courtesy of MSU.)

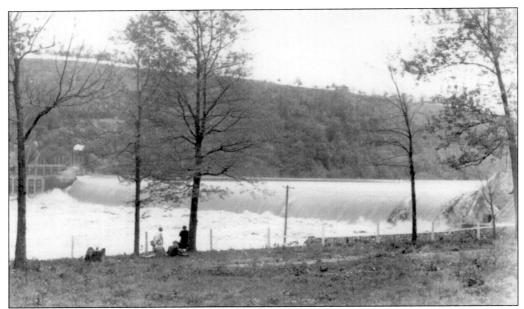

In February 1938, Lake Taneycomo overflowed, with water more than 13 feet high roaring over the Powersite Dam. Families evacuated their homes, while several tourist camps along the bank flooded. The lake level had reached an all-time high. Major highways were closed, and communication was interrupted. The Table Rock Dam was built as part of the Flood Waters Control Act of 1938 and 1941. (Courtesy of MSU.)

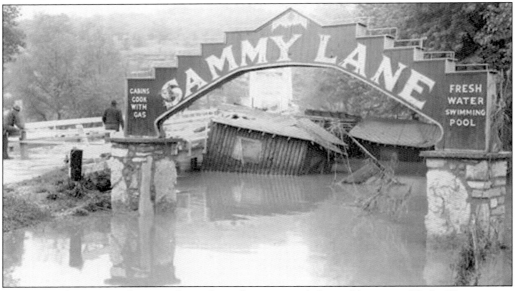

In 1943, a downpour of over eight inches of rain caused the sudden rise of Lake Taneycomo, which forced families and businesses to evacuate without their belongings. The Main Street Bridge in Branson was condemned after its middle pier was damaged. The entrance to the Sammy Lane Resort was completely underwater during the May 1943 flooding of the White River and Lake Taneycomo. Route 80 to Hollister over the Branson Main Street Bridge was closed as well. (Courtesy of MSU.)

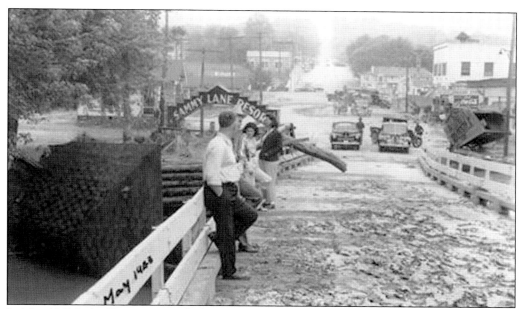

In May 1943, Lake Taneycomo spilled over its banks, threatening Branson, Hollister, and Forsyth for two weeks in a row. Fortunately, citizens had received enough warning to move their belongings out of harm's way. The floodwaters crested at nearly 19 feet over the Powersite Dam, just shy of the 1927 record of 19.1 feet. Closed due to structural damage, the Branson Main Street Bridge was photographed covered with flood debris. (Courtesy of MoDOT.)

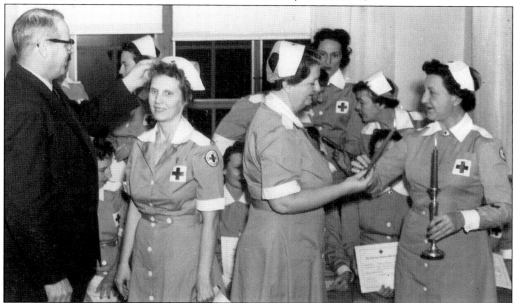

The Main Street Bridge across Lake Taneycomo opened on July 4, 1913. During the flood of 1945, about 10 cabins from the Sammy Lane Resort and others lodged against the bridge. The bridge suddenly folded in and washed away. With all bridges underwater or destroyed, Forsyth was completely cut off from surrounding areas. The Red Cross disaster crews, headquartered in Springfield's Colonial Hotel, were dispatched by boat to Branson. (Courtesy of MSU.)

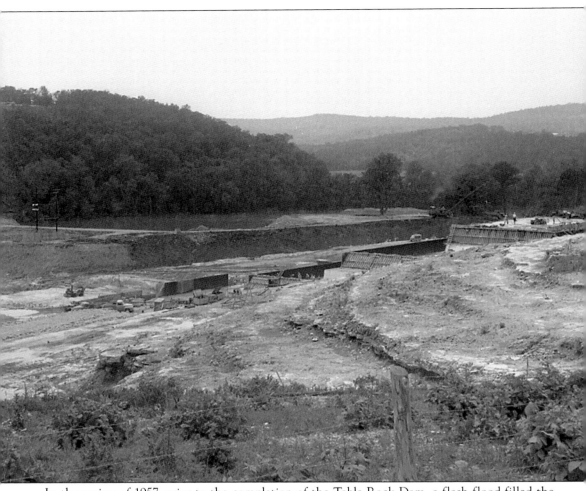

In the spring of 1957, prior to the completion of the Table Rock Dam, a flash flood filled the new Table Rock Lake in just three days. With the Table Rock Dam under construction, the bombardment of massive amounts of water destroyed the new forms and equipment, delaying completion for a year. The Kimberling City Bridge was in the process of being dismantled when the flood hit; it now rests over 100 feet underwater. (Courtesy of BCM.)

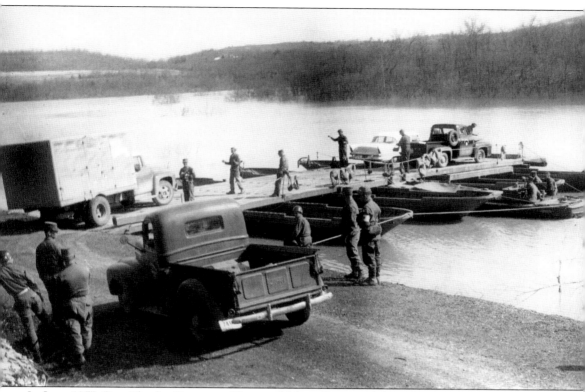

In June 1957, Sgt. Charles Horton, a 23-year-old from Eutaw, Alabama, drowned when he fell from a ferry, which the 5th Army Engineers of Fort Leonard Wood had begun operating when April flooding washed out two bridges. On the last day the Army Engineers were to operate the vessel, Horton was knocked off the ferry as it docked on the Branson side of the river. (Courtesy of WRVHS.)

In the Ozarks, hunting and fishing are a way of life. Subsistence farmers in the Ozarks supplemented their food with wild game, hunting deer, wild turkey, rabbits, and squirrels for meat. The white-tailed deer, once abundant in Missouri, rapidly declined in population following the influx of settlers at the end of the 19th century. Settlers destroyed deer habitats with their farms and grazing land. By 1900, white-tailed deer and wild turkeys had become endangered in the Ozarks, while black bears and large cats had been eliminated altogether. By 1925, an estimated 400 deer were all that remained in Missouri. Missouri's state legislature closed deer-hunting season, and Michigan deer were released into the Ozarks. With a small harvest, deer season reopened in 1931. From 1938 to 1943, deer hunting was prohibited, and additional Michigan, Wisconsin, and Minnesota deer were introduced. In 1944, the statewide deer population topped 15,000, so deer season once again reopened. Branson resident Louis King proudly presents his 10-point buck from the bed of his pickup in downtown Branson in the late 1950s. (Courtesy of WRVHS.)

Eight

AREA ATTRACTIONS

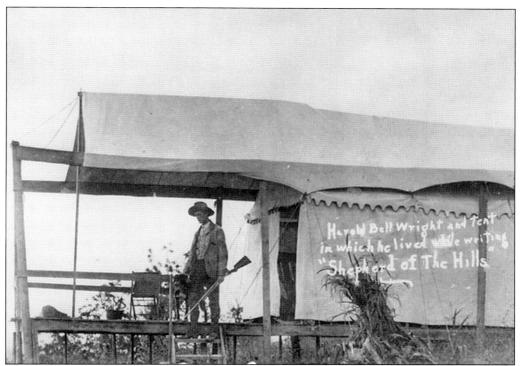

From 1896 to 1905, Kansas preacher and author Harold Bell Wright visited the Ozarks to improve his health. Having developed pneumonia as a young man, Wright later contracted tuberculosis. He came to the Ozarks as an avid fisherman and nature lover. Escaping flooding on the White River, Wright pitched a tent in the field of John K. Ross, which later became known as Inspiration Point. Ross and his wife, Anna, and their son, Charles, welcomed Wright over the years, whenever he wished to return. The Rosses became known as the real-life versions of "Old Matt," "Aunt Mollie," and "Young Matt," the characters of Wright's book *The Shepherd of the Hills*. During his stay, Wright walked five miles each day to the Notch Post Office, where he learned about the region from Notch postmaster Levi Morrill, who became known as "Uncle Ike" in Wright's book. This real-photo postcard details Wright and the tent he lived in while writing his book. (Courtesy of Gerry Chudleigh.)

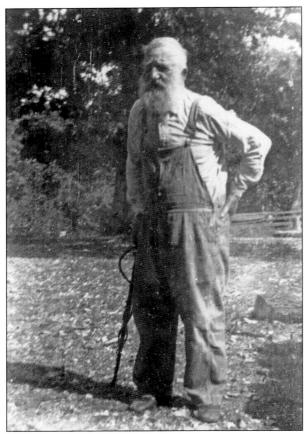

Levi Morrill (seen at left in 1923) came to the Ozarks in 1888 from Lamar, Missouri, where he had owned a weekly newspaper. He and Truman Powell came to explore the "Devil's Den," which later became Marble Cave. After conducting the first recorded exploration of the cave and its vicinity, Morrill and Powell moved their families to the area. Powell later served as the 44th and 50th General Assembly representative, while Morrill became the Notch postmaster (below). On August 19, 1922, Morrill's 85th birthday, the *Springfield Leader* reported on Wright's characters from *The Shepherd of the Hills*: "Mr. Morrill was the only one who had not been 'worked over.' The other characters were created in the brain of the author after his association with natives of the Ozarks had given him inspiration." "The Shepherd" was partially modeled after Powell. (Both, courtesy of WRVHS.)

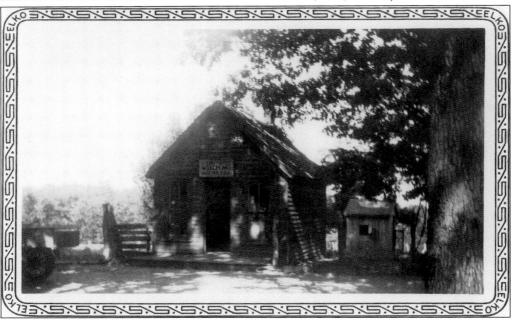

The Shepherd of the Hills heroine, "Sammy Lane," may be a composite of Susie B. Morrill and Grace Shearer. Susie, Levi Morrill's daughter, rode a pony named Brownie. Grace lived in both Mutton Hollow and Lawrence County at the same time as Harold Bell Wright. Both were friends with the Rosses' son, Charles, who resembled "Young Matt." This 1910 advertising postcard was labeled as "Sammy's Lookout with Browny." (Courtesy of Springfield Museum on the Square.)

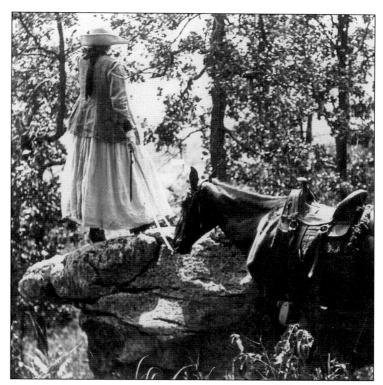

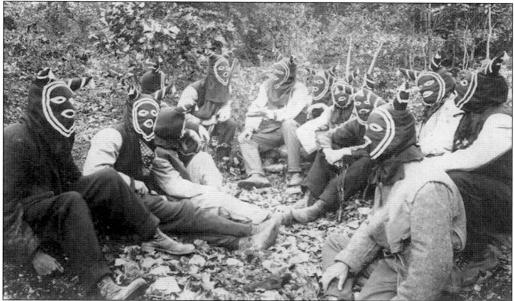

In June 1918, Harold Bell Wright brought his publisher, Elsbery Reynolds, to the Branson area. Wright planned to produce a movie version of *The Shepherd of the Hills*. Wright mentioned the Bald Knobbers in the book but had them disbanded prior to the story taking place. The Wash Biggs Gang from Wright's book contained former Bald Knobbers. Locals portrayed his characters and even dressed in the infamous Bald Knobbers masks. (Courtesy of Gerry Chudleigh.)

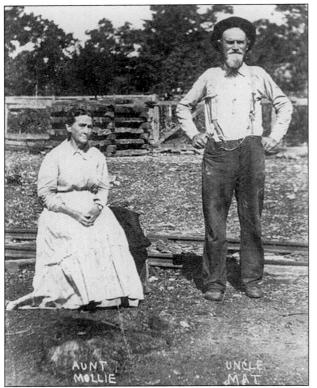

AUNT MOLLIE UNCLE MAT

Harold Bell Wright stated that "Old Matt" and "Aunt Mollie" bore resemblance to John K. Ross and his wife, Anna, (at left) with whom Wright had stayed during his visits between 1896 and 1906. After the publication of *The Shepherd of the Hills* in 1907, tourists hounded the Rosses. In late 1910, they moved from Old Matt's Cabin to Garber, Missouri. An unidentified child peeks from the doorway while Ross (below) poses on the porch of the general store and post office, which Joel B. Garber had built. The sign on the building reads, "Fourth Liberty Loan, Wear Your Honor Button." In October 1918, the US government issued the fourth liberty loan bonds to help pay for the country's involvement in World War I. "Uncle Matt" and "Aunt Mollie," as the tourists and tour guides called them, lived in Garber until their deaths in 1923. (Both, courtesy of Gerry Chudleigh.)

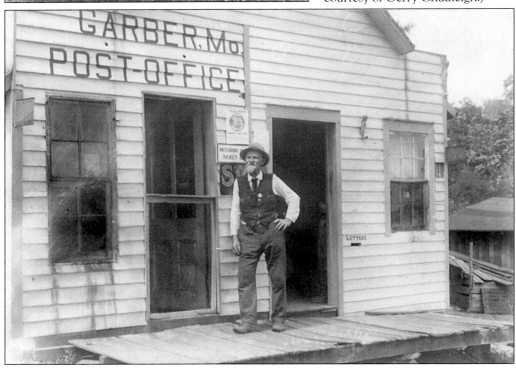

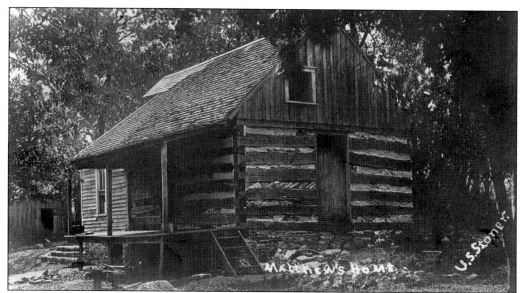

The Rosses sold Old Matt's Cabin (above) to William L. Driver, who turned it into a diner. He added a screened dining room on the north side, and by the end of the first season, more than 600 tourists had dined there. Driver and his new wife, Sarah S., moved to California in 1926. They sold the homestead to Springfield banker Horace Dewitt McDaniel for just $3,000, which would be less than $39,000 today. Lizzie McDaniel King then received the homestead from her father. The next year, Lizzie began reenacting *The Shepherd of the Hills* on the lawn. In 1934, her Springfield home was dismantled and moved near the cabin. Lizzie is shown seated in her living room (below). Dr. Bruce and Mary Trimble purchased the homestead in 1946, following Lizzie's death, and eventually turned Lizzie's home into a second museum. (Above, courtesy of Gerry Chudleigh ; below, courtesy of BCM.)

**The Ross Memorial Committee
announces the dedication
of the
Memorial to
Old Matt and Aunt Molly
of the
"Shepherd of the Hills"
Sunday, October 4th, 1925
at 3:30 p. m.
In the Shepherd of the Hills Cemetery**

Through the efforts of Pearl "Sparky" Spurlock, Isaac M. Thompson, and R.E. Smith of Branson, the Shepherd of the Hills Cemetery was plotted in the heart of the Wright landmarks. It was established as a resting place for people who knew Harold Bell Wright and had become prototypes for his characters. The unveiling of the Ross Memorial, honoring the real-life "Uncle Matt" and "Aunt Mollie" made famous in Wright's *The Shepherd of the Hills*, occurred on October 4, 1925. Dr. Robert M. Good, president of the School of the Ozarks, presided, with an address given by John G. Neihart, well-known poet and Branson resident. Levi Morrill, also known as "Uncle Ike," stood between Good and Neihart, next to the flag-draped monument. Its cost of $250 was split among Wright; his publisher, Elsbery Reynolds; his father, William A. Wright; and public donations. (Both, courtesy of Dave Hadsell.)

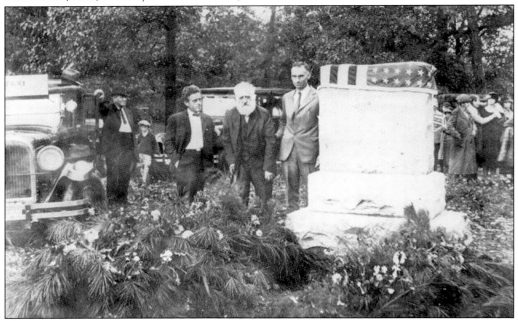

After purchasing Inspiration Point in 1946, Dr. Bruce and Mary Trimble decided to hold a competition inviting artists to paint a model for sculptors to use that would depict the characters of *The Shepherd of the Hills*. Missouri muralist Thomas Hart Benton judged the contest, won by Wally Nickel, a 15-year-old student at the School of the Ozarks. Springfield art teacher Roberta Stoneman Baker sculpted the seven-foot figure of "the Shepherd," which went on display in 1954. Statues depicting "Aunt Mollie" and "Little Pete" were added in 1955. All three were photographed in October 1955. Michael Lee sculpted statues of "Old Matt," "Young Matt," and "Uncle Ike" soon afterward. Dr. Trimble died before his planned amphitheater was built, but his wife, Mary, and their son, Mark, completed the project. The Old Mill Theater opened in 1959. Over the years, the amphitheater has been expanded. In 1985, new owner Gary Snadon gave the property its current name, the Shepherd of the Hills Homestead and Outdoor Theater. Opened in 1988, Inspiration Tower rises 243 feet above the statues. (Courtesy of Lucile Morris Upton.)

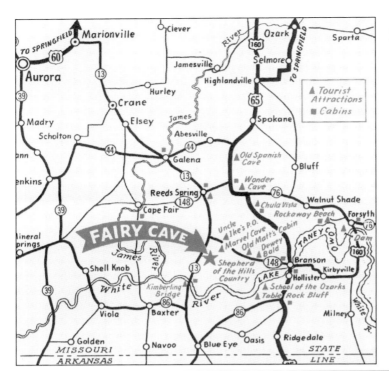

Articles written by newspaper publisher and spelunker Truman S. Powell publicized the exploration of Marble Cave in 1882. In 1907, the Powells purchased nearby property with another cave, which opened in 1921 as Fairy Cave. In the 1950s, adult admission was $1, and children paid 50¢. The family owned the property until the 1970s, when the Herschend family (who owned Silver Dollar City) purchased the site, renaming it Talking Rocks Cavern. (Author's collection.)

Miriam, Genevieve, and their father, William Henry Lynch, reopened Marble Cave for visitor tours in 1894. Led by the girls themselves, the tours were quite strenuous, often lasting for six hours. Until 1932, candles lit the way, as kerosene lanterns were considered too dangerous for the average visitor to use. Sightseers climbed down a ladder into the Cathedral Room. Eventually, stairs were built for easier access. By 1918, the Lynches acknowledged their cave's misnomer, since the cave contained no marble, and they began referring to it as Marvel Cave. (Courtesy of BCM.)

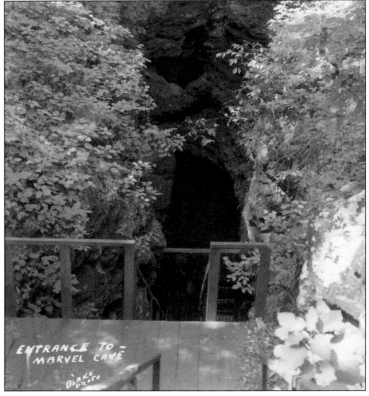

Described as "the Wonder Cave of the Shepherd of the Hills Country," the Marvel Cave entrance shows the wooden stairs leading down into the Cathedral Room. As attendance increased, William H. Lynch built a road to Branson. Slender automobile tires dug deep ruts in the road. Lynch carried guests from town by wagon for just $5 apiece, which included room and board, a cave tour, and round-trip transportation. (Courtesy of BCM.)

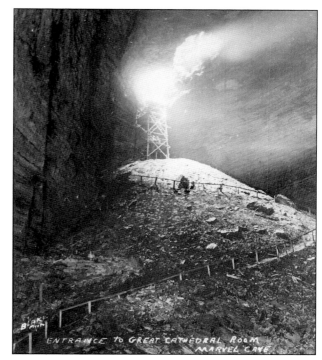

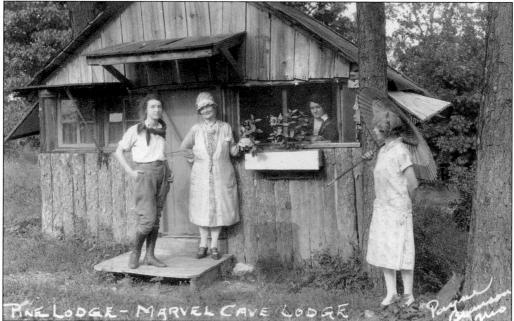

As the daughters of William H. Lynch, owner of Marvel Cave, Miriam and Genevieve Lynch owned and operated the Marvel Cave Lodge and Camps. They were just opposite "The Forks," the famous Notch Post Office run by Levi Morrill, the real-life "Uncle Ike." Four unidentified women pose at the Pine Lodge. Also available were Blinkbonnie, Dreamerie, Harold Bell Wright Camp, and Honeymoon Camp. (Courtesy of BCM.)

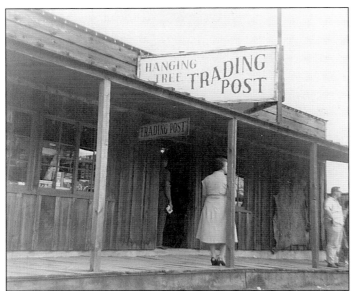

In 1950, the Lynch sisters leased the cave to Hugo and Mary Herschend. After the installation of electric lights that year, square dances were held in the cave on a regular basis. Hugo passed away in 1955, so Mary continued making improvements to the cave and to the town, which she renamed Silver Dollar City. The Hanging Tree Trading Post at Silver Dollar City was photographed in 1964. (Author's collection.)

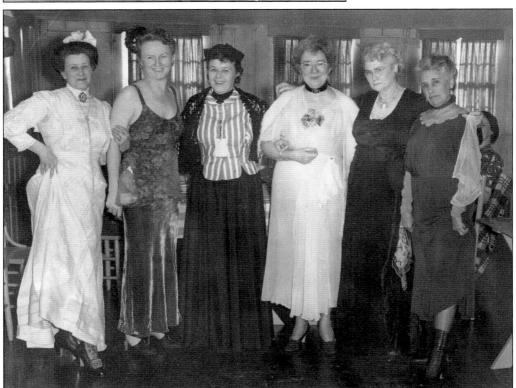

In April 1960, over 3,000 people enjoyed the cakewalks, horseshoe pitching, hog calling, marble games, mumblety-peg, fishing contests, footraces, and concerts held during the Plumb Nellie Days (Plumb Nearly Anything Goes Days), which has now become an annual event. Dressed for the Plumb Nellie Festival in their old-fashioned finery are, from left to right, Ellie Mitchell, unidentified, Josephine Madry, Dee McClure, Lea Kingdon, and Ann Thompson. (Courtesy of BCM.)

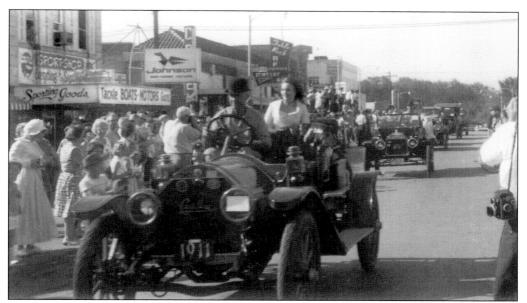

In 1962, several vintage automobiles, including a 1911 Cadillac, participated in the Plumb Nellie Days parade. Plumb nearly anything was permitted during the event, including crafters, artists, and food vendors peddling their wares, as well as live entertainment and a Friday-night street dance with live music. Today, activities range from Reuben Branson Look-Alike Contests to sidewalk sales sponsored by the Downtown Branson Main Street Association. (Courtesy of BCM.)

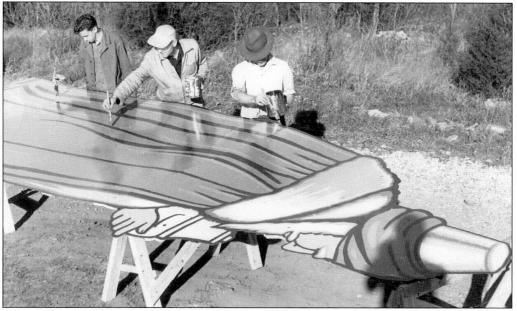

In 1948, furniture store owner Joe Todd, local artist Steve Miller, and Owen Theatre manager Evert Williams developed the Adoration Scene. Preparing a 20-foot-high figure for the first lighting event in 1949 are, from left to right, Delbert Beasley, Steve Miller, and Evert Willams. The 12 figures spanned 300 feet across. Each year, thousands visited the nationally famous scene, which was visible up to five miles away at night. (Courtesy of BCM.)

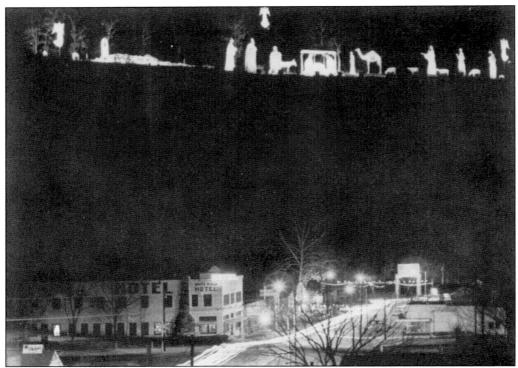

In 1951, the Branson Chamber of Commerce purchased the site on Mount Branson where the crèche scene is displayed, and permanent concrete bases were set to support the huge figures. In 1953, three guardian angels were added to the scene. Pictured from across Lake Taneycomo in 1960, the huge figures of the Adoration Scene on Mount Branson appear suspended like apparitions overlooking Branson. The White River Hotel is visible as well. (Courtesy of BCM.)

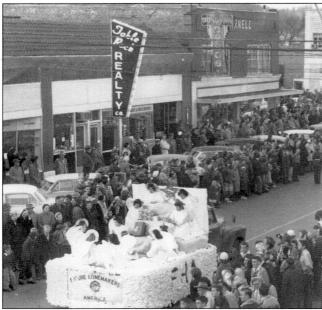

In 1953, the Branson chapters of Future Farmers of America, Branson-Hollister Rotary Club, Branson Metro Club, Kiwanis of Taneycomo, and the Branson Chamber of Commerce sponsored the Taney County Dairy Festival in June and the Adoration Parade in December. Over 40 merchants donated prizes, including free goods, services, and accommodations for the Dairy Festival. Porter Waggoner performed and hosted the square dance. Contests included pie eating and fiddling. (Courtesy of WRVHS.)

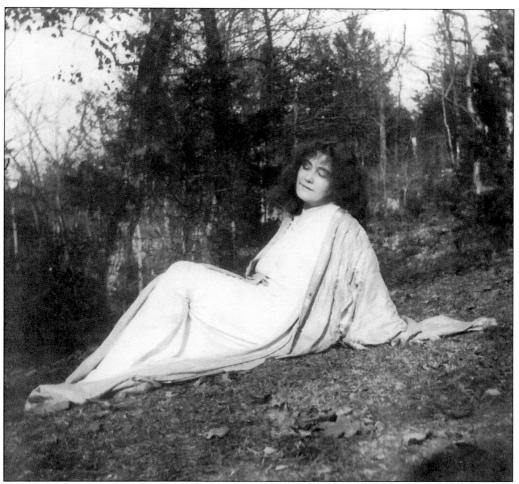

William Patrick O'Neill relocated from Omaha, Nebraska, to an abandoned Ozarks homestead in 1893. By 1898, construction had begun on a 14-room Ozark mansion that his daughter Rose O'Neill financed and named Bonniebrook. Located north of Branson off US 65, Bonniebrook was the first home in Taney County with a telephone, indoor bathroom, and electricity. Rose was a novelist, poet, sculptor, painter, political activist, and suffragist. In 1909, she created the Kewpies, which became the most widely known cartoon character prior to Mickey Mouse. By 1914, she was the highest-paid female illustrator in America. In 1936, Rose retired to Bonniebrook to be with her mother, Alice Asenath O'Neill, who passed away the following year. Rose died in 1944, and a fire completely destroyed Bonniebrook three years later. In 1975, the Bonniebrook Historical Society began rebuilding the house, completed in 1993, which was 100 years after the O'Neill family began homesteading there. Today, Bonniebrook houses the Rose O'Neill Art Collection and the Kewpie Museum, with hundreds of antique Kewpie items. (Courtesy of David O'Neill.)

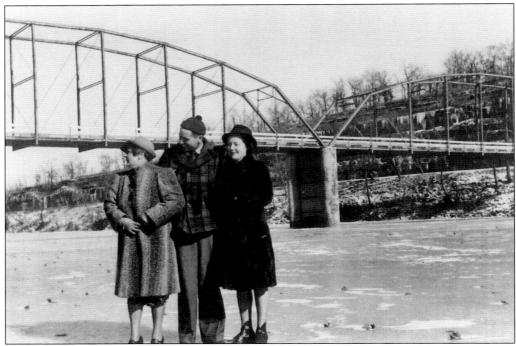

In the 1950s, an unidentified friend posed to the left of Don and Jill Gardner when they were photographed in front of the original Main Street Bridge on frozen Lake Taneycomo. In 1938, the Gardners opened the Golf Ranch Country Club on Highway 80 (now E-76). By bartering for what they needed, the Gardners turned a pasture into a golf course, known today as the Holiday Hills Resort and Golf Club. (Courtesy of BCM.)

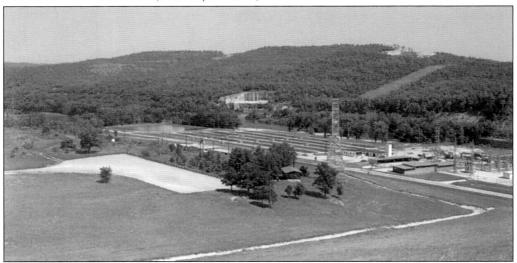

The Shepherd of the Hills Fish Hatchery is located on 211 acres in the cold-water region below the Table Rock Dam. With 84 acres currently developed, it is the largest trout production facility operated by the Missouri Department of Conservation. Begun in 1957, the hatchery annually produces 1,125,000 catchable rainbow and brown trout, weighing about 300,000 pounds. Lake Taneycomo receives 700,000 new trout yearly. (Author's collection.)

Senator Dewey Short from Galena, Missouri, was instrumental in the development of Table Rock Dam and Lake. Beginning in the 1930s, Short supported the development of highways, reservoirs, and hydroelectric power in the White River Valley area. Closed following 9/11, the Dewey Short Visitor Center once again welcomes visitors for guided tours inside the Table Rock Dam and Powerhouse, offered from March through December. (Courtesy of Ralph Foster Museum.)

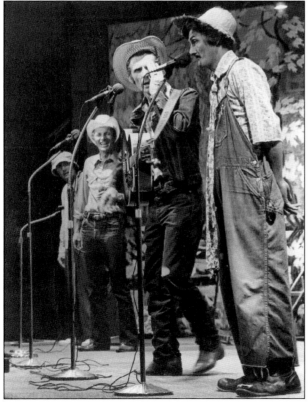

The Mabe brothers—from left to right, Lyle, Bob, Bill, and Jim—began a musical career singing on Springfield's KWTO radio. They became Branson's first live entertainment troupe in 1959, performing as the Baldknobbers Hillbilly Jamboree Show in Branson's American Legion. They entertained audiences from the old Sammy Lane Pavilion and then an old skating rink on Lake Taneycomo before moving to the Baldknobbers Theatre at 76 Country Boulevard in 1968. (Courtesy of WRVHS.)

DISCOVER THOUSANDS OF LOCAL HISTORY BOOKS
FEATURING MILLIONS OF VINTAGE IMAGES

Arcadia Publishing, the leading local history publisher in the United States, is committed to making history accessible and meaningful through publishing books that celebrate and preserve the heritage of America's people and places.

Find more books like this at
www.arcadiapublishing.com

Search for your hometown history, your old stomping grounds, and even your favorite sports team.